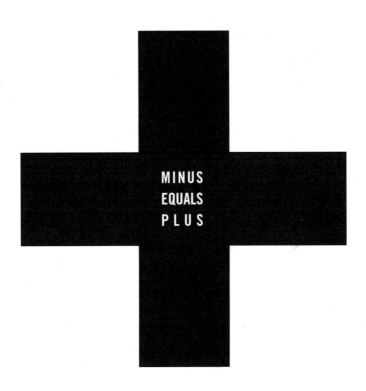

MINUS
EQUALS
PLUS

INTRODUCTION BY KURT ANDERSEN

HARRY N. ABRAMS, INC., PUBLISHERS

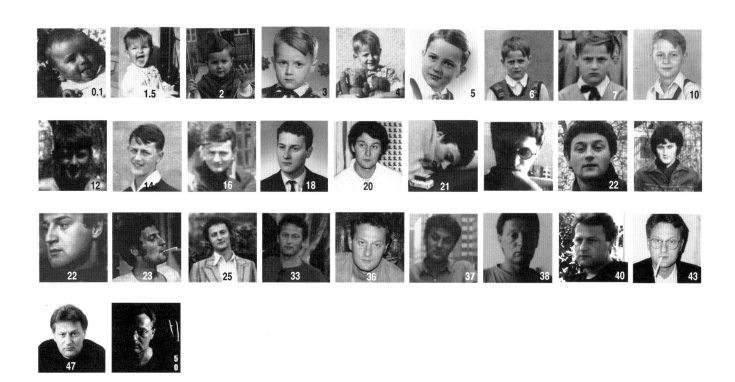

A decade ago, I discovered that reading bedtime stories to one's children is pretty much everything it's cracked up to be, the paternal equivalent of breast-feeding (but only once a day and without the sore nipples). Once the kids turned three or so, they still liked my funny fairytale voices, but they also wanted books they could read—that is, "read"—themselves. So for a couple of years I spent lots of time leafing through children's picture books. And I discovered that the great majority were mediocre or worse—banal, treacly, shallow, half-assed, depressingly Barneyesque. The pictures tended to be either badly drawn or skillful in the manner of hotel-room art. But then I stumbled across Istvan Banyai's first *Zoom* book. I was floored. *Zoom* is awesome, fun the way a fantastic toy is fun: conceptually ambitious, elegant, well made, a little masterpiece with as much charm and surprise per page as any book ever. Like all first-rate entertainment nominally for children—*The Wizard of Oz, Loony Tunes*, the books of Maurice Sendak and Maira Kalman, *The Simpsons*—*Zoom* is deep and complicated, as pleasurable for adults as for kids. ✚ Around the same time, I happened to become editor of *New York* magazine and used the opportunity to hire Istvan to illustrate an essay that led the magazine each week. The drawings he did were delightful and strange and regularly superb, but they never thrilled me as much as *Zoom* had. Which was not Istvan's fault: I had fallen in love with a thirty-page, mind-blowingly self-contained work of art, whose effect was achieved sequentially, by turning pages. So I proposed a *Zoom* magazine project to Istvan, a seventeen-page New York City narrative that Absolut vodka would sponsor and we would bind into an issue of *New York*. The result was a layered revelation of a lusciously post-apocalyptic Manhattan, a kind of Borges for Dummies. For one sweet moment, a mass medium had been re-engineered to accommodate the art and artist, rather than vice versa. ✚ After I left *New York* in 1996, so did Istvan, but I started noticing his work (and imitations of his work) everywhere. And in the aggregate, panel by individual

panel in newspapers and magazines, I began to glimpse Istvan World in all its fantastic completeness. Whether it was a Nickelodeon promotional film or a drawing on the *Times* Op-Ed page or an illustration for a *New Yorker* essay, nearly every piece seemed plucked from a single, vast panorama. As with all interesting artists, the individual works exist as puzzle pieces, bits of a whole. ▪ Istvan World is a trippy place. It's surreal, but not harsh and solipsistic and smirky like so much surrealist art. It's rooted in the real world of history and goofy individual humanity, and wears its weirdness lightly. It neither tries too hard to be contemporary and happening, nor recycles a single historical style into the ground, but seems (like life, and like certain great art) to be a singular, organic, and accidentally wonderful fusion of the visual tropes and fashions of many eras as well as its own. ▪ In addition to the turn of the twenty-first century, I see in Istvan's work distinct traces of several earlier periods—eras, not unlike this one, marked by giddy expansiveness and flux. There are whiffs of the post-Victorian decades just before and after World War I, the two generations encompassing Arthur Rackham, Luigi Pirandello, L. Frank Baum, M. C. Escher, J. M. Barrie, Gluyas Williams, George Grosz, René Magritte, and—especially—Winsor McCay, the creator of the *New York Tribune* comic strip *Little Nemo in Slumberland.* Like Istvan, McCay was a young immigrant pulled irresistibly to a robust, fin de siècle Manhattan to work as a magazine and newspaper illustrator and to make animated films. Istvan's work, unlike McCay's, is mostly denuded of social and urban context (thus its floating, out-of-time quality), but the precision, miniaturist density, and Midsummer's Night whimsy occupy the same splendid universe, a place of farce and gravitas intermingled. (This universe has been around for a long time, of course: Istvan's softly psychedelic Twilight Zone was also familiar to readers of Jonathan Swift—Banyai drawings teem with Brobdingnagians and Lilliputians—and Lewis Carroll.) ▪ Istvan World was also colored by the 1960s and early 1970s. He is a younger countercultural cousin of Maurice Sendak and Seymour Chwast, of Kurt Vonnegut and *Yellow Submarine*'s George Dunning and Heinz Edelmann, of Peter Max (before Max devolved into Leroy Niemanism), and the artist who drew the original Playboy Party Joke vixens. ▪ There are bits in Istvan World of other times and places as well. For instance, I think I detect residue of 1980s Tokyo. But the Western avant-garde at the last turn of the century also borrowed from Asia, as did the sixties psyche-deloids, so from where and when exactly did Istvan pick up those Japanese bits? In our perpetually recycling, ferociously globalized twenty-first century, it becomes hard to say. Which is what help makes Istvan World familiar, even in its queerness. ▪ Of course Istvan Banyai also makes animated movies; it would be shocking if he didn't. *Zoom* and *Re-Zoom* are, in essence, short films frozen ingeniously between hard covers. With their limpid colors, precise lines, and minimalist backgrounds, nearly all his print pieces resemble animation cels. His predilection for radical, swoopy angles—Istvan is the master of the two-dimensional

crane shot—give the drawings cinematic energy. Istvan is to other illustrators as Orson Welles or Vincente Minnelli were to assembly-line, proscenium-arch movie directors of the 1940s. ✛ I have a general weakness for artists struggling happily against the confines of their media, trying to make old-fashioned technologies do what they've never done before: the creators of mechanical men in the eighteenth century, Otto Wagner's proto-modernist architecture at the last turn of the century, Ernie Kovacs in 1950s television—and Istvan Banyai now. Istvan's game is more quixotic, since he is making his pen-and-brush movies-on-paper by choice, like an engineer hand-crafting biplanes in the Space Shuttle age. ✛ In other words, Istvan embodies and celebrates paradox. His line can be loose and sketchbookish, or obsessive and virtuosic—and sometimes both at once. Istvan World is gleeful and mischievous but also faintly melancholic, like a toy store in a Mitteleuropa never-never land. It's sweet and good-naturedly curious but never faux-innocent—ghastly overgrown brats abound. Istvan World seems always to be coming apart at the seams, but the entropy has its charming, even beautiful aspects . . . and, indeed, may not be disintegration at all, but a metamorphosis into some kooky new state of harmony. It's dreamlike, but dreamlike in a matter-of-fact, everyday

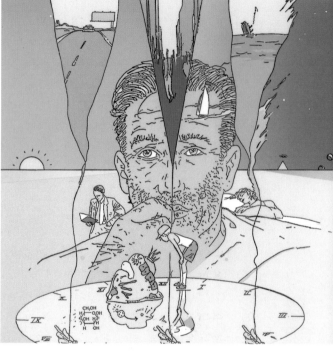

way—the way young children seem to experience the world. ✛ A few weekends ago, as I watched my youngest daughter blowing soap bubbles over the grass toward the afternoon sun, I thought of Istvan's work. She was passing time, having fun, but my sense is that she's just old enough also to sense the complicated mixture of delight and sadness that soap bubbles inspire: perfect transparent spheres, drifting away on an autumn breeze, jewel-like follies always seconds away from disappearing. ✛ "Life as a zoom," Istvan faxed me a few days later, offering an unsolicited attempt to explain his work. "One sunny afternoon in Budapest, kicking a football to a brick wall as a five-year-old or so, wondering, 'Why am I here?' . . . but the neighbor came out and asked me to make noise somewhere else before he kicks me on the ass . . . and interrupted the flow of any possible insight . . . nothing new ever since!" ✛ Exactly.

—Kurt Andersen

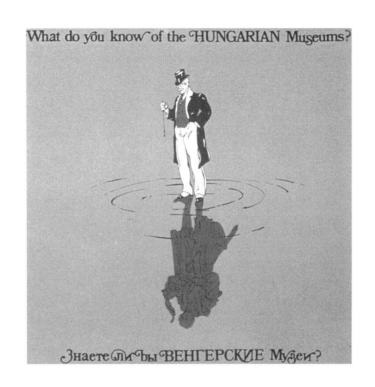

POCO

COWBOYs

& Englishmen

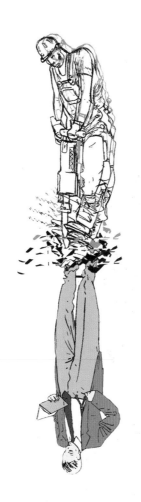
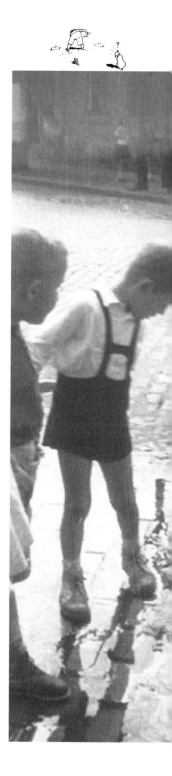

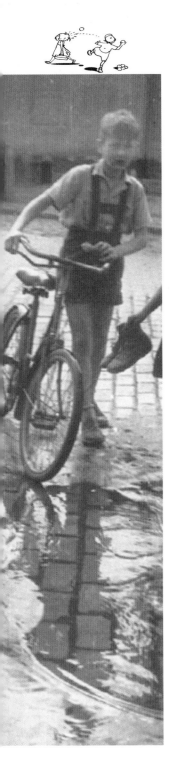

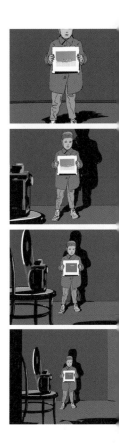

12

9 3

6

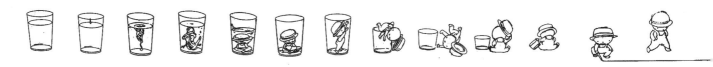

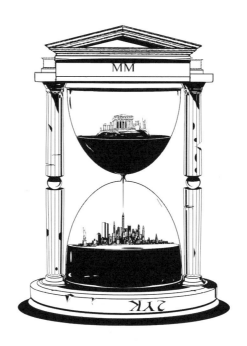

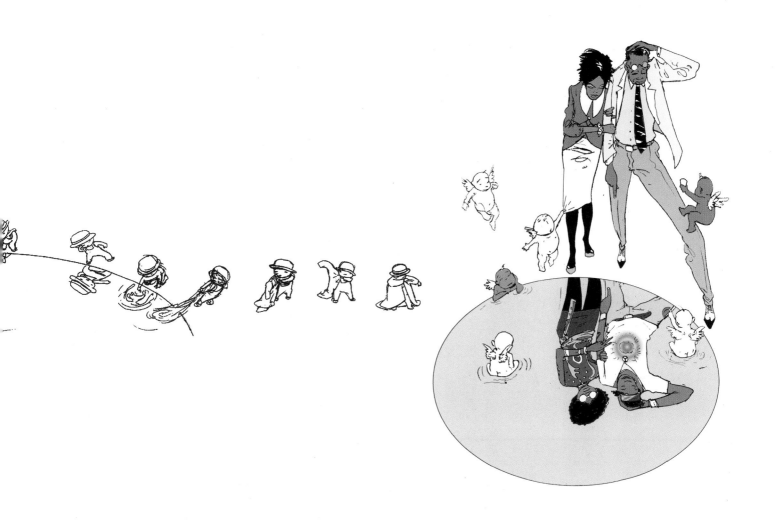

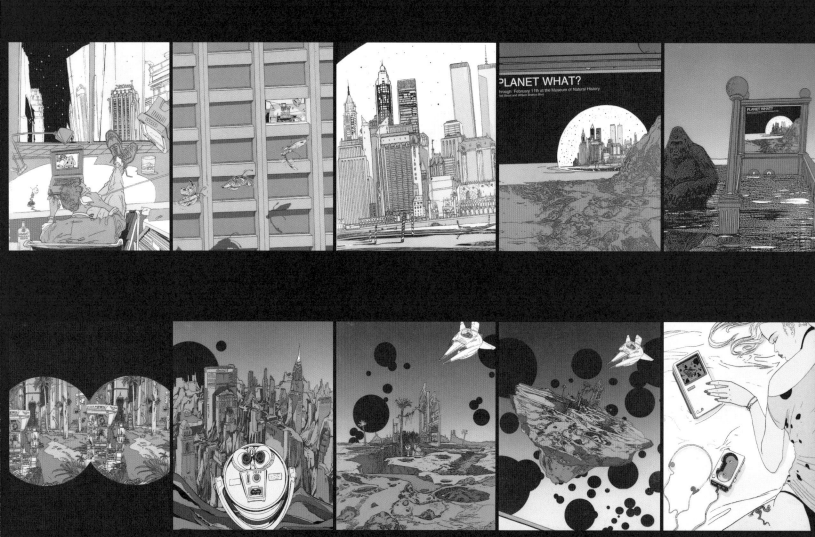

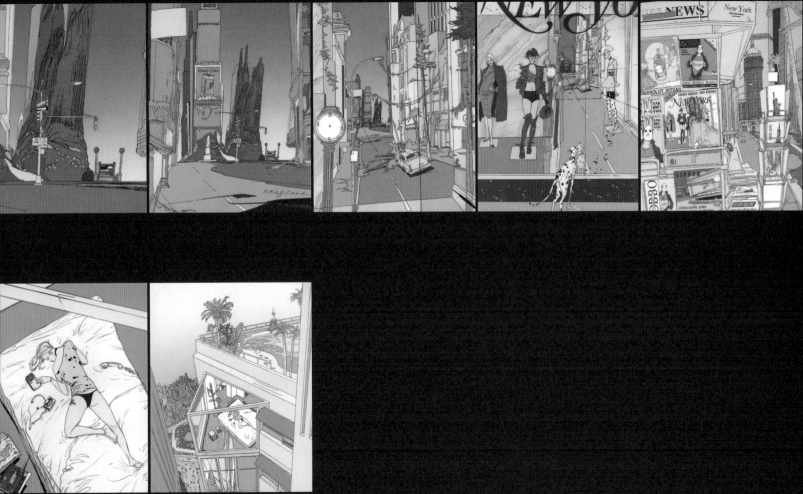

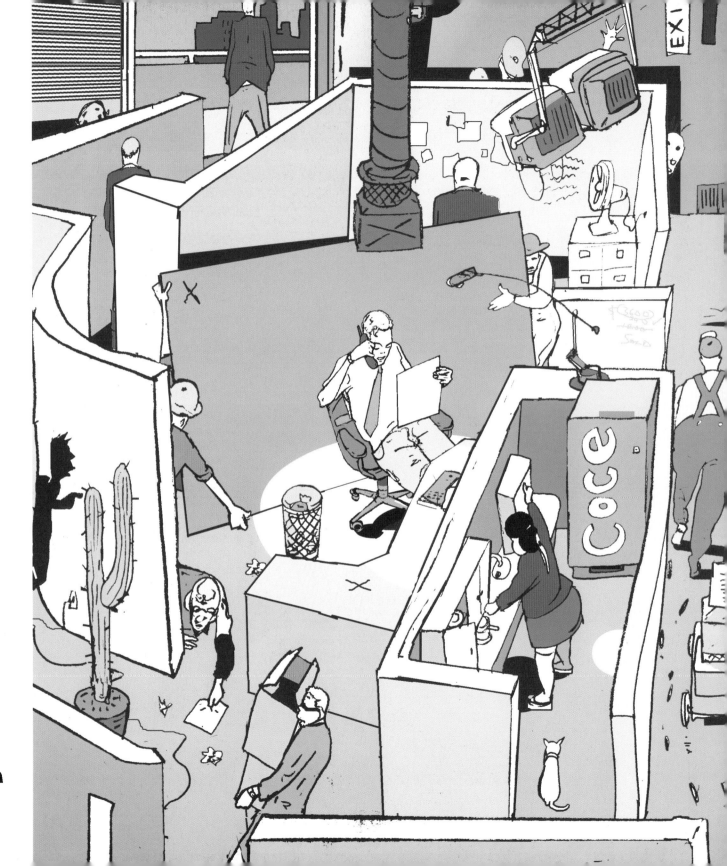

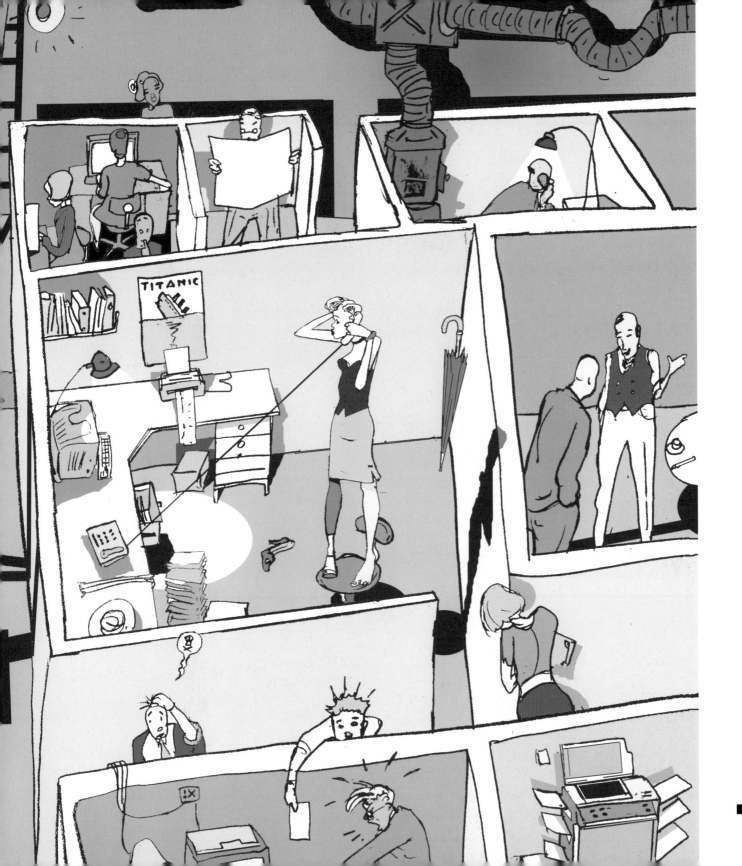

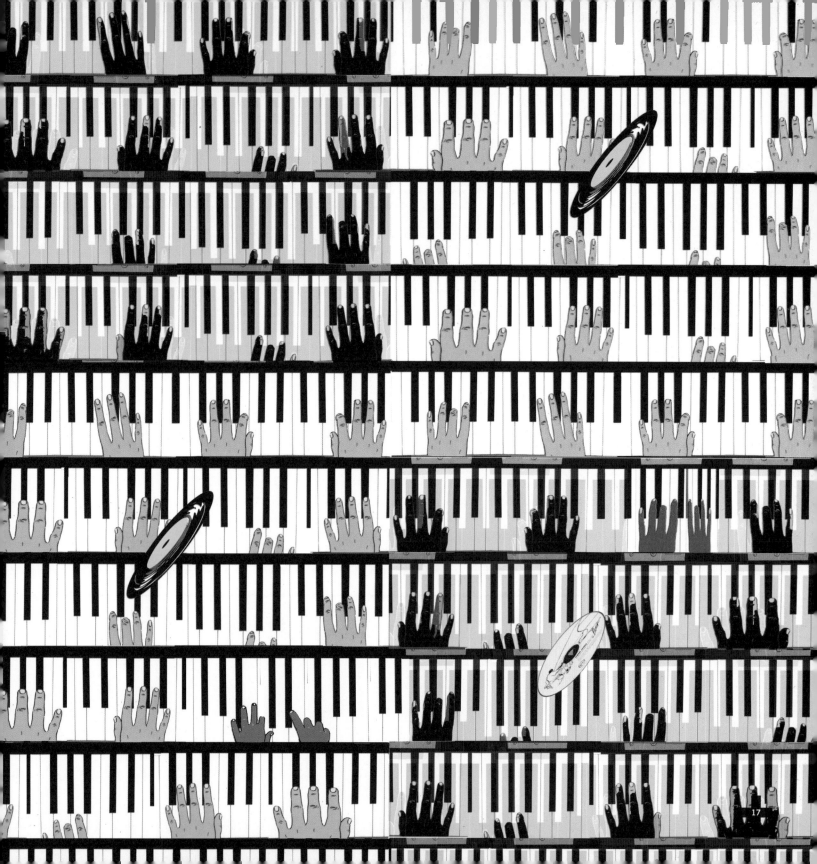

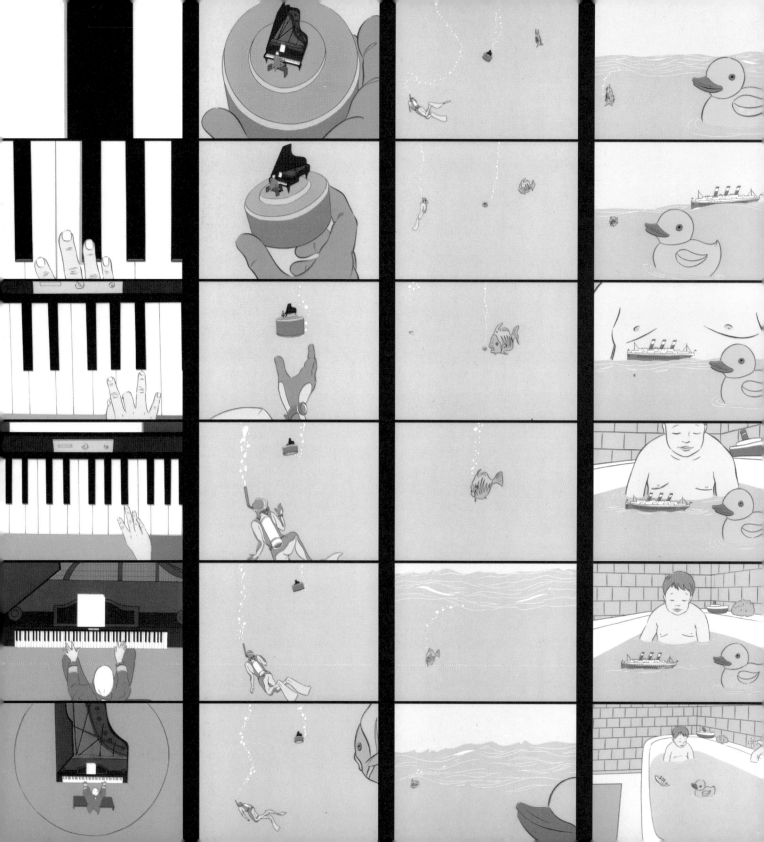

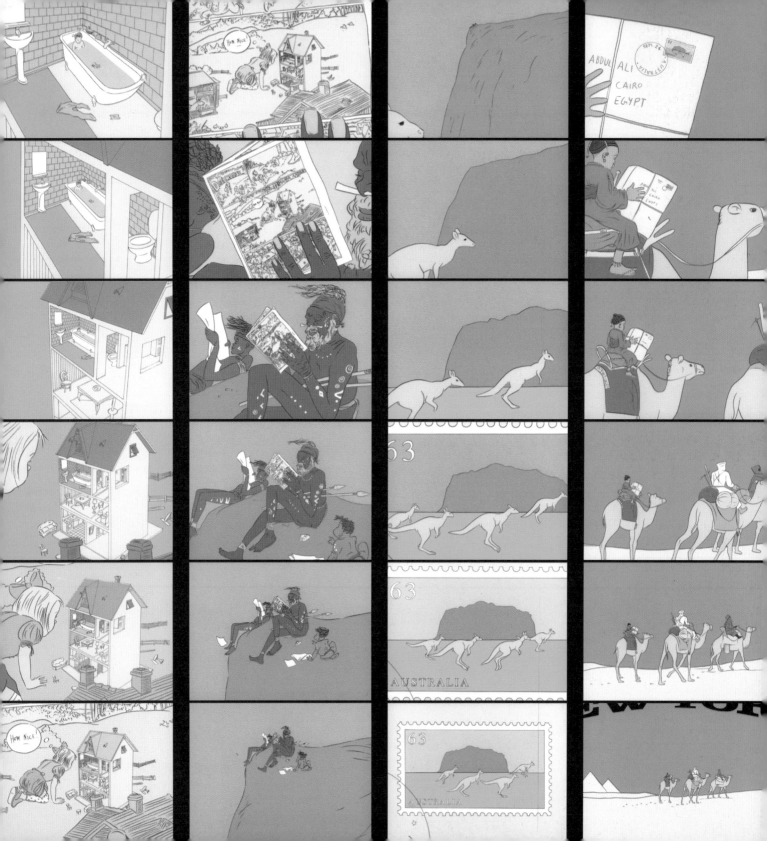

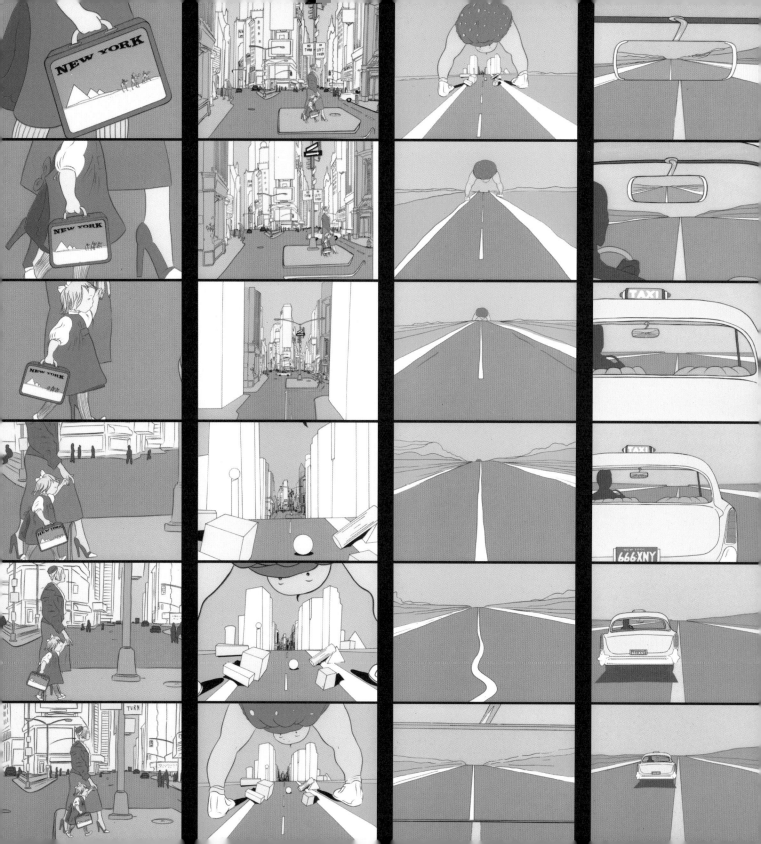

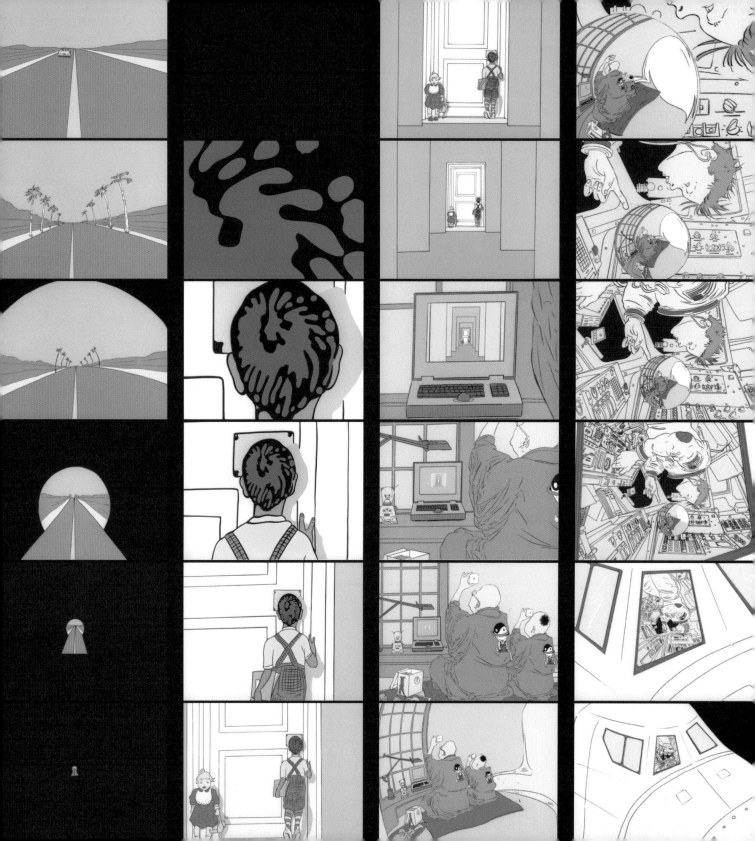

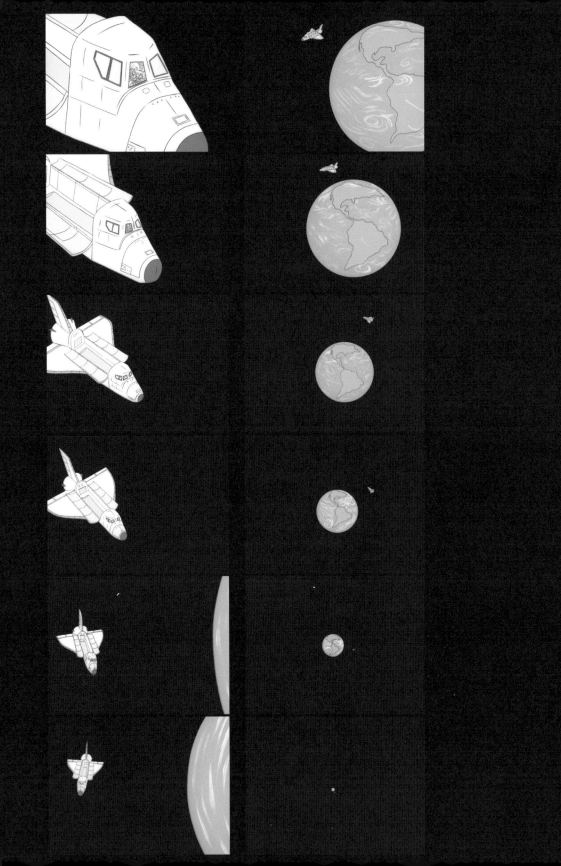

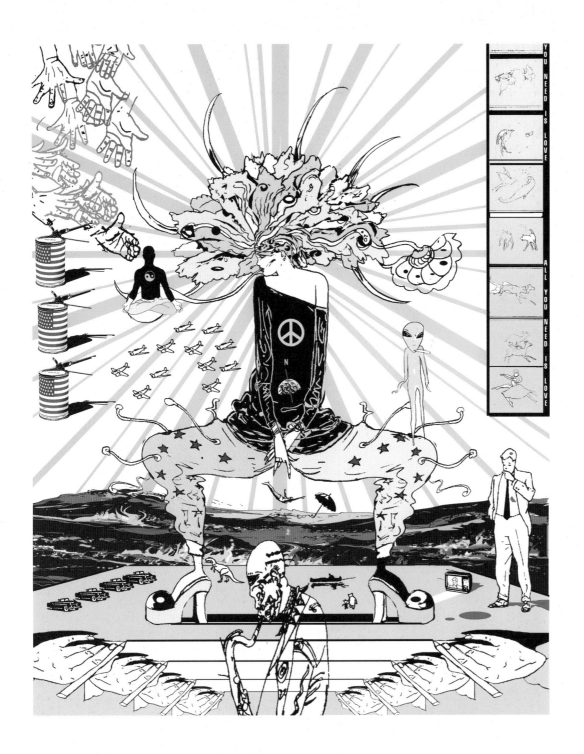

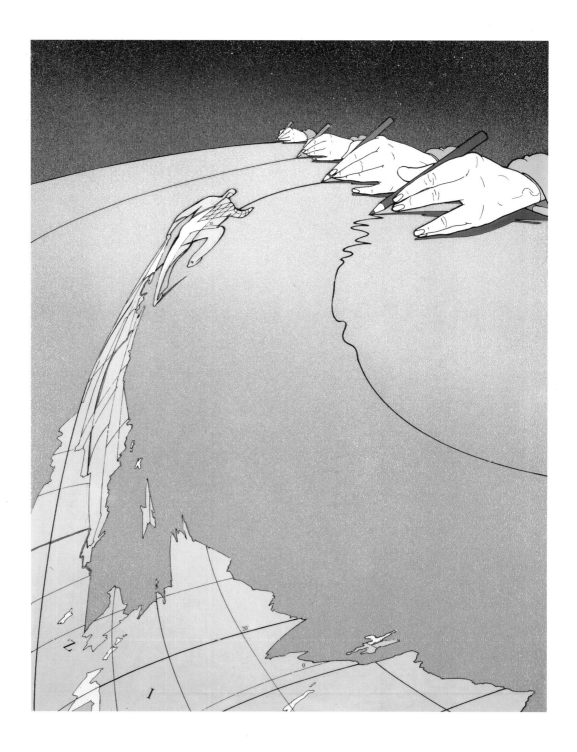

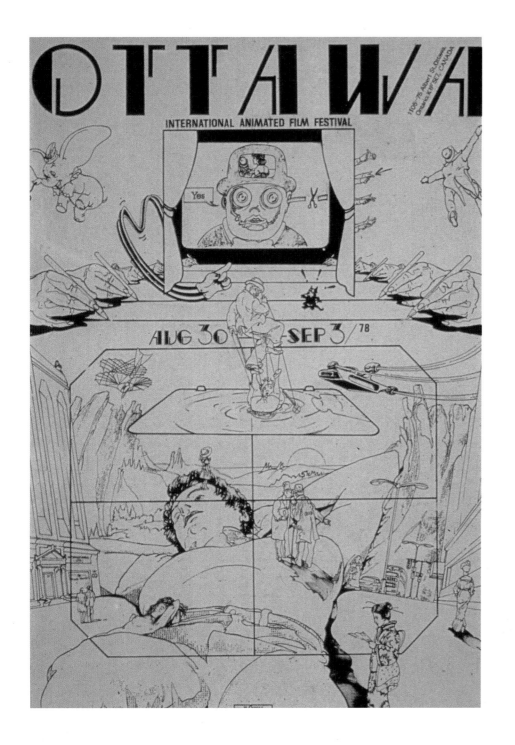

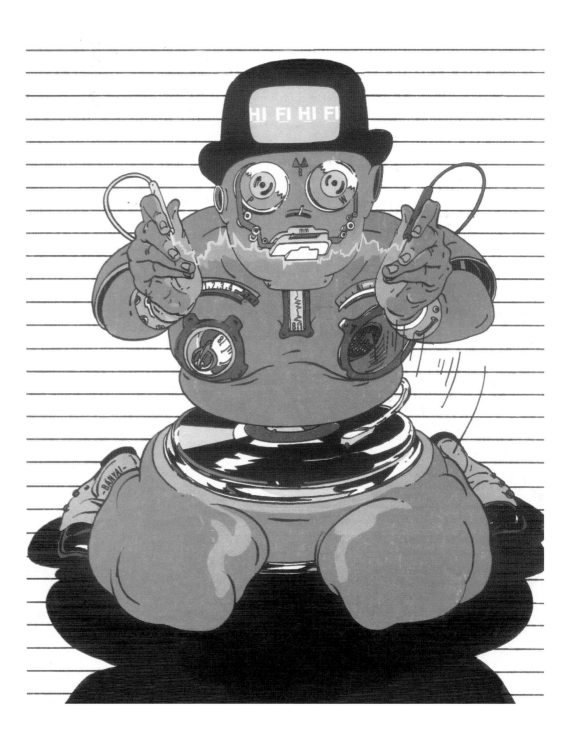

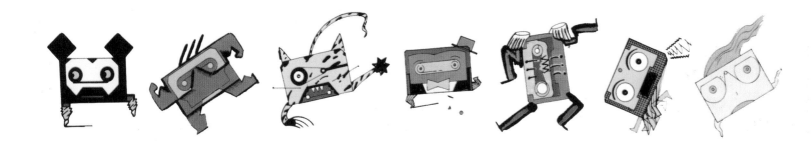

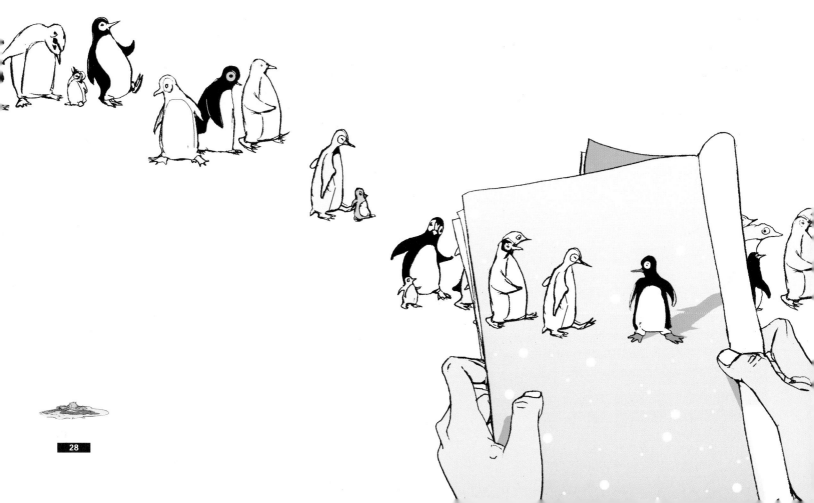

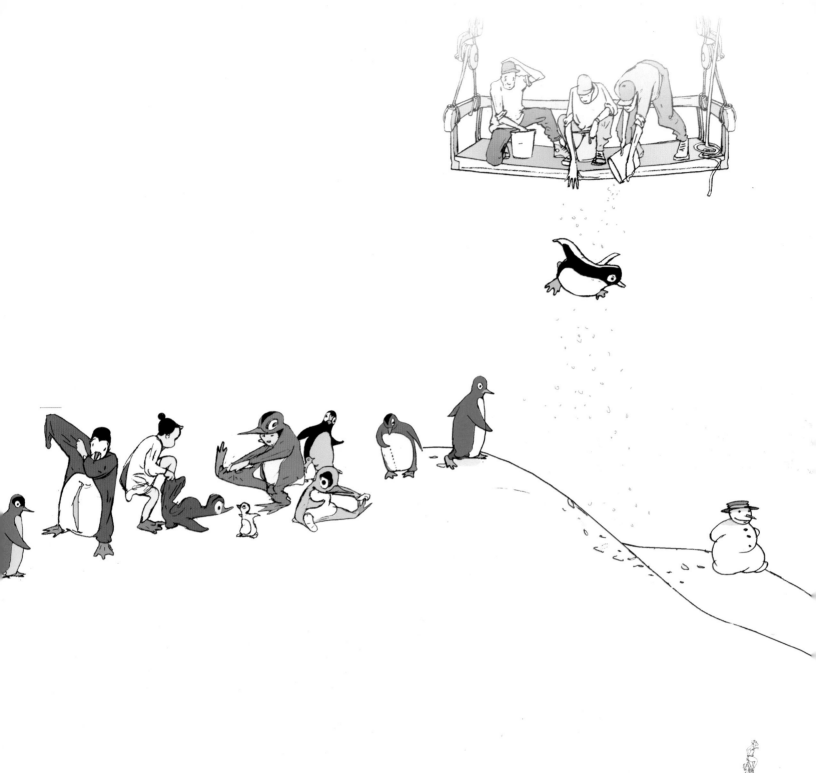

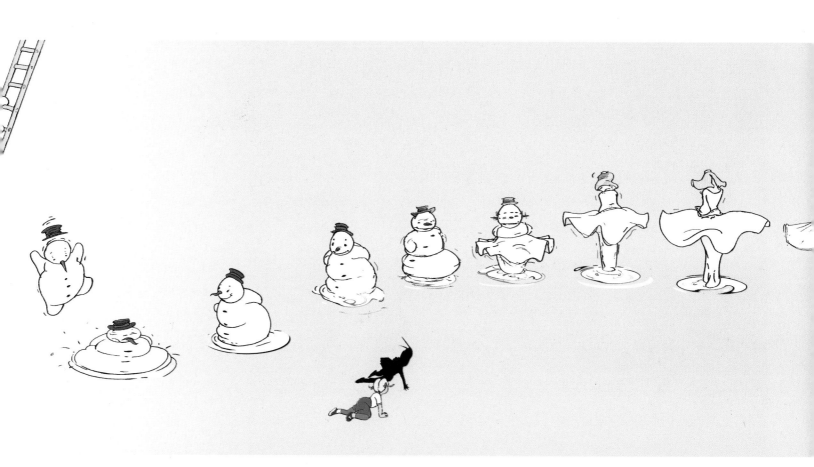

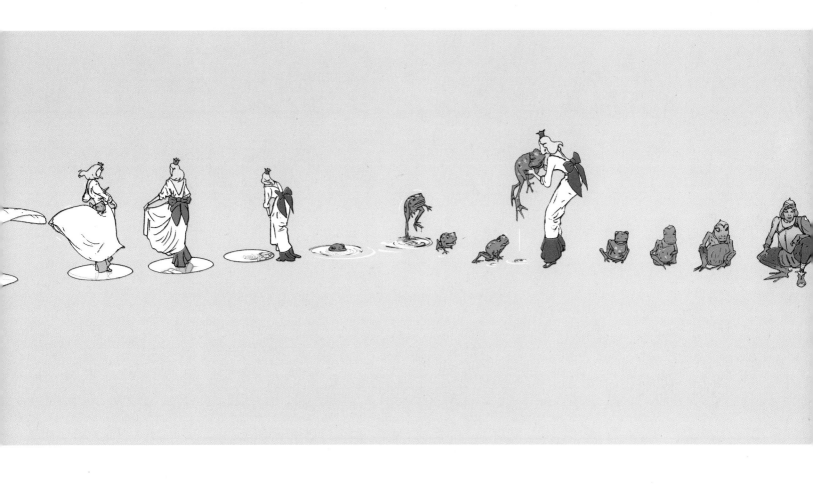

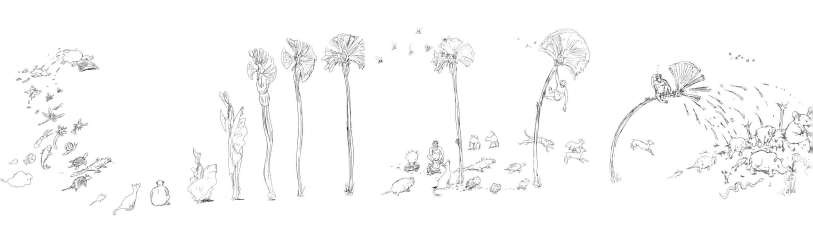

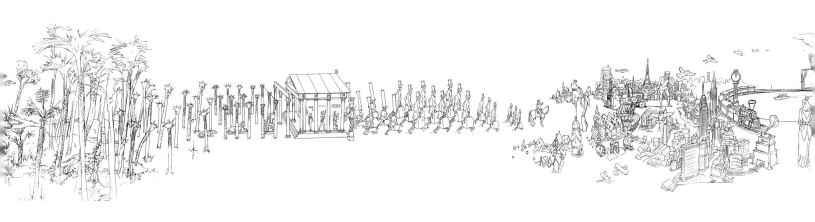

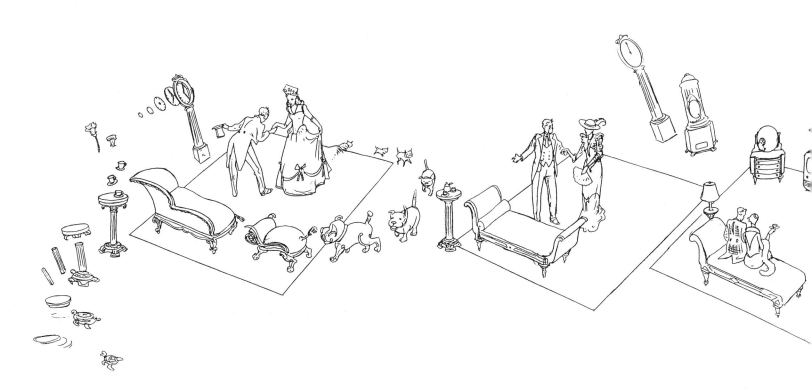

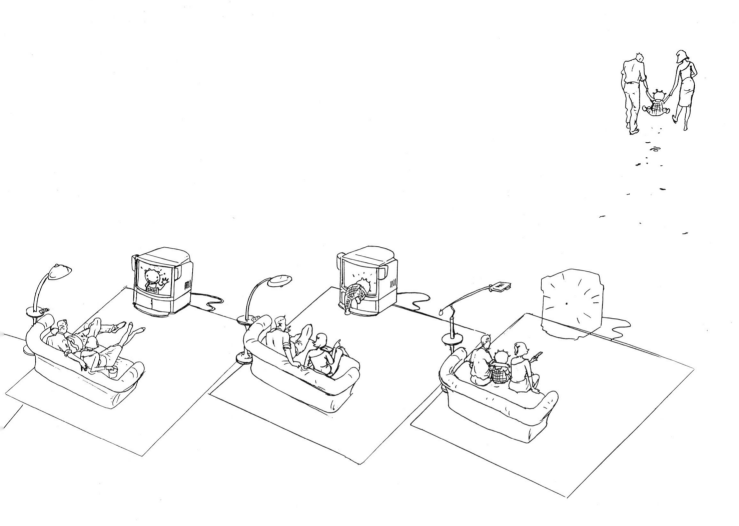

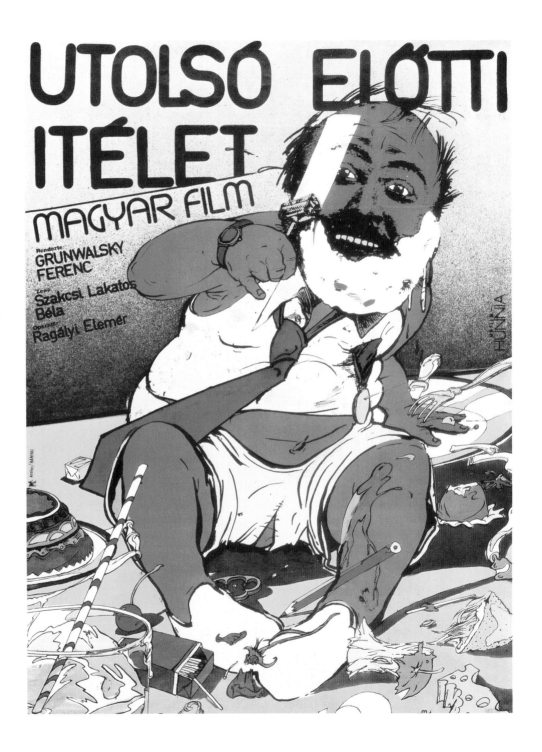

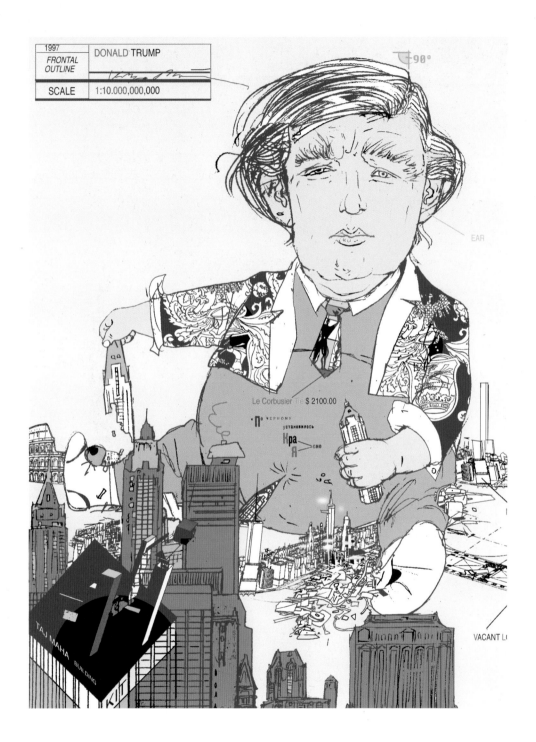

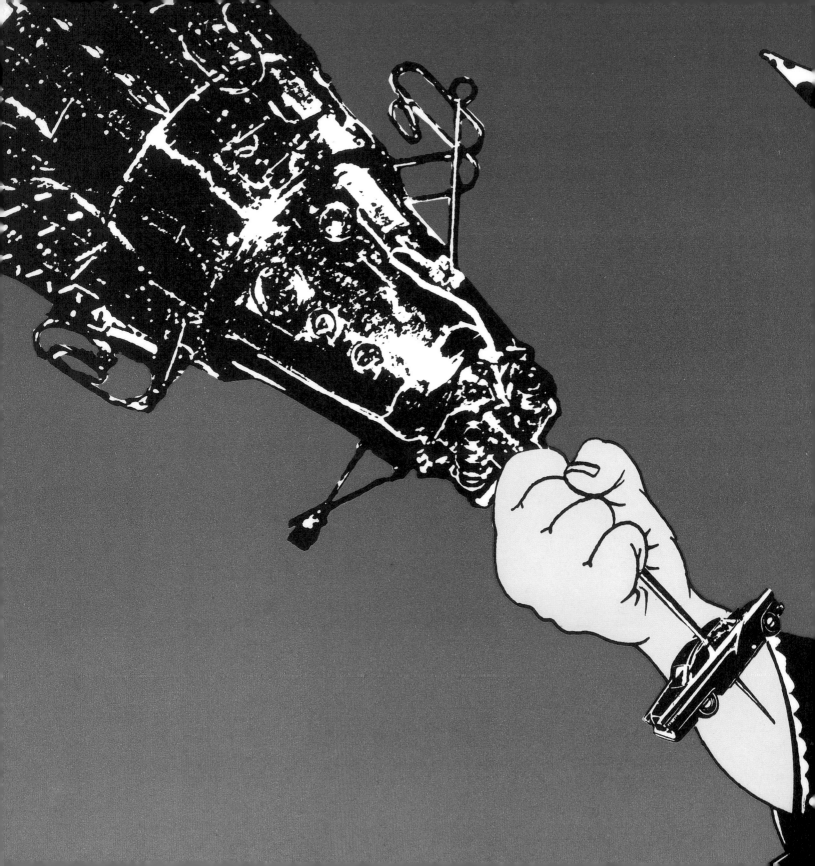

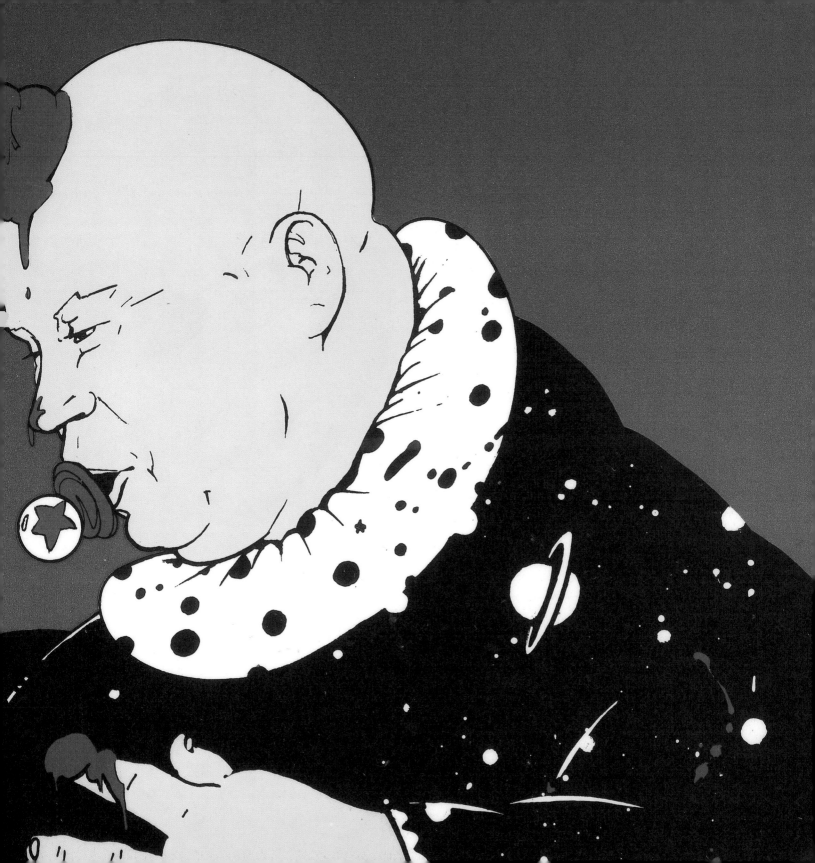

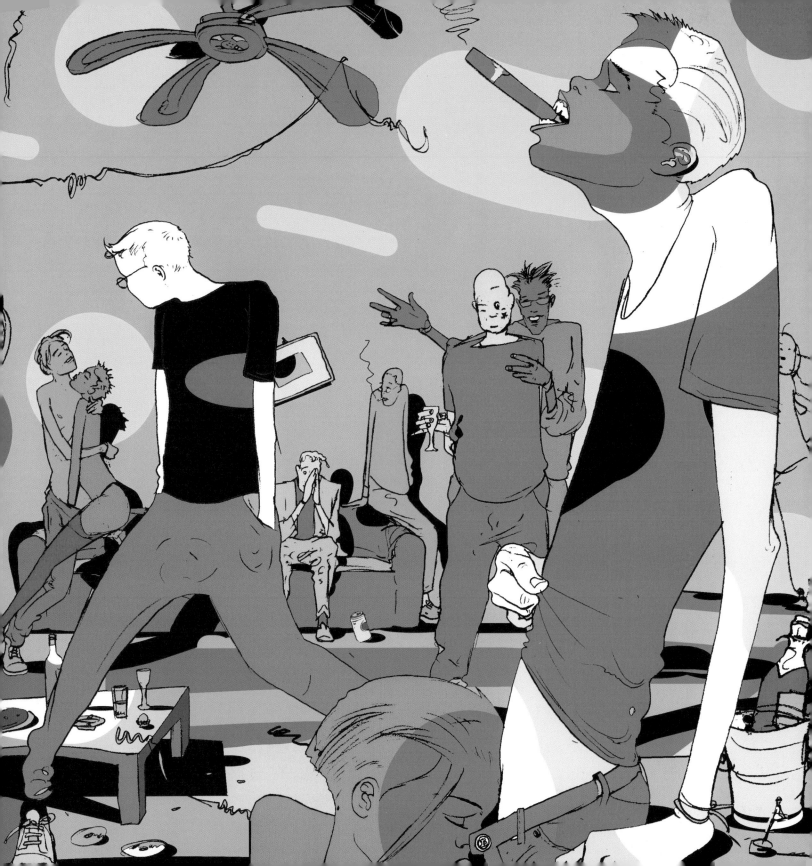

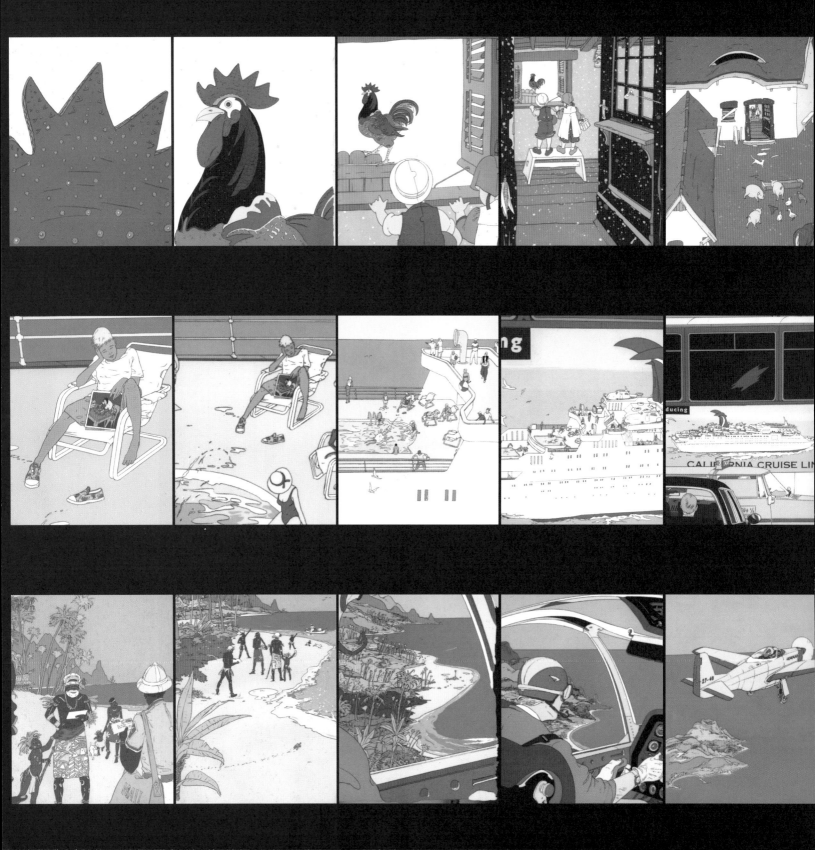

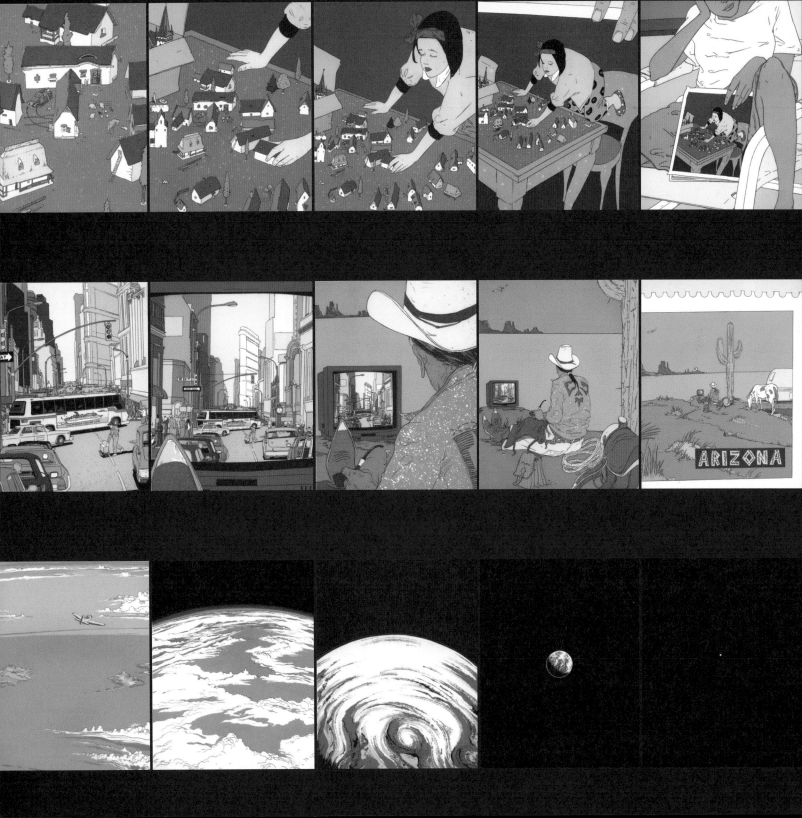

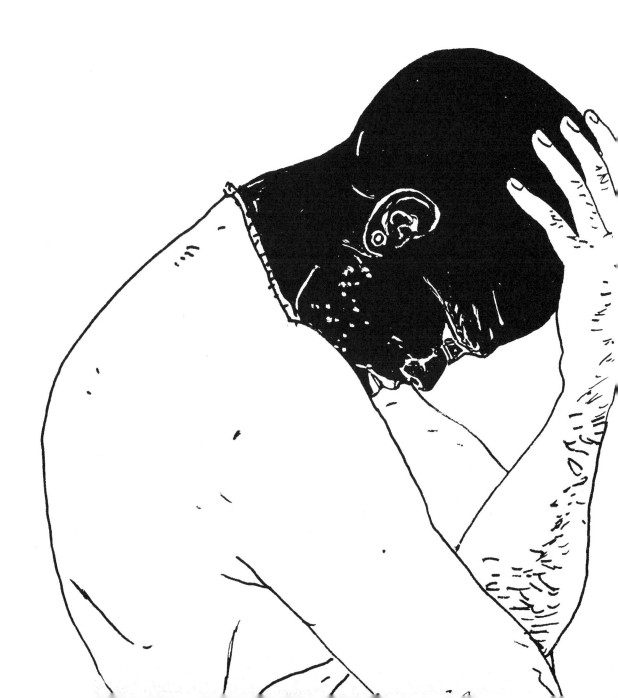

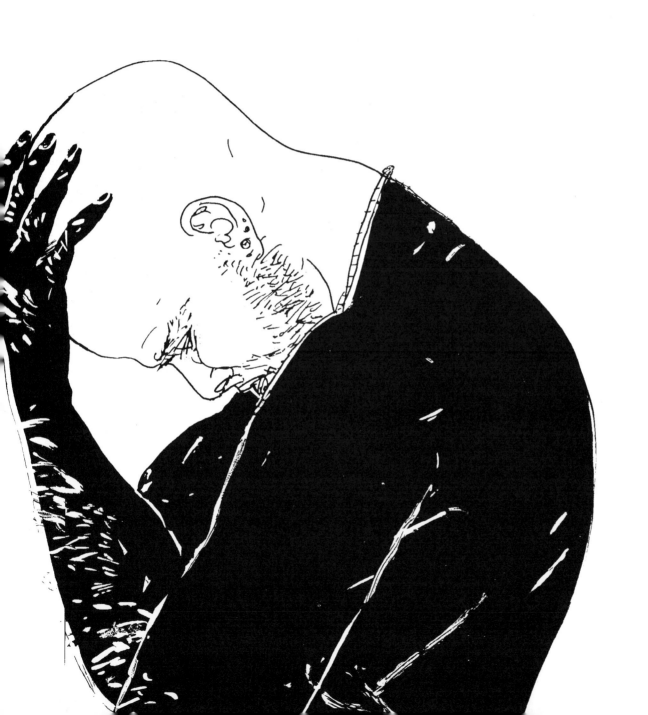

47

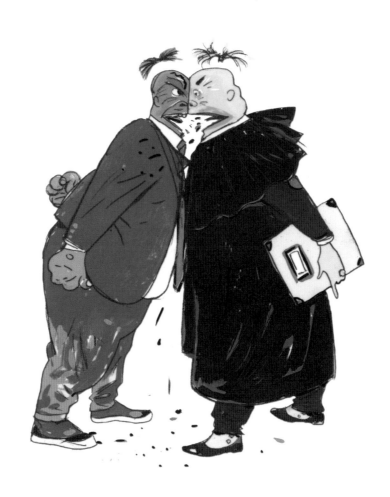

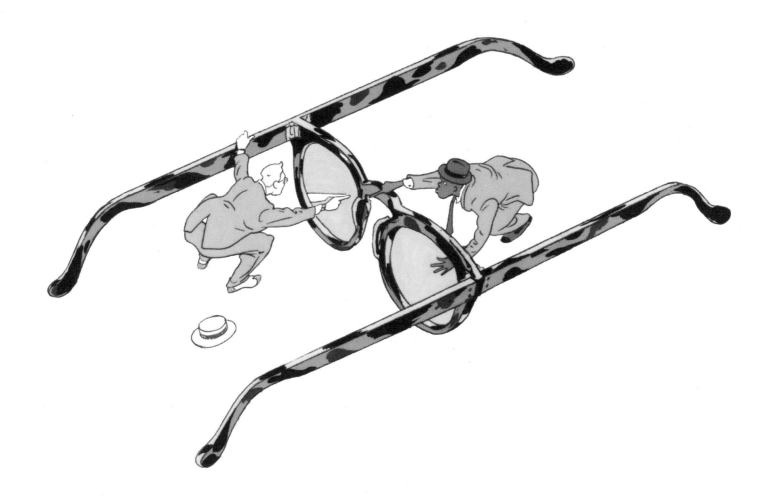

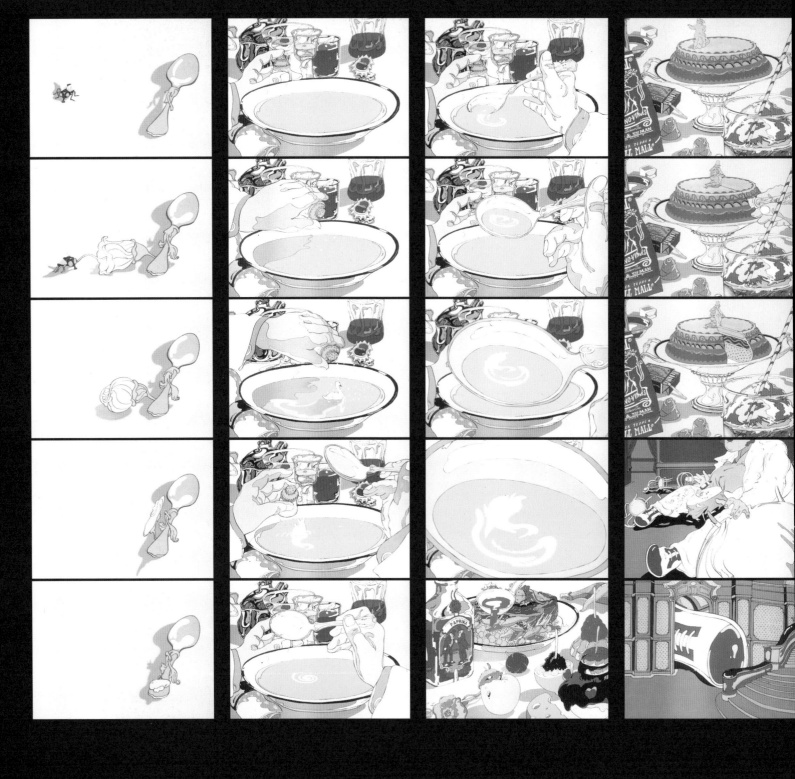

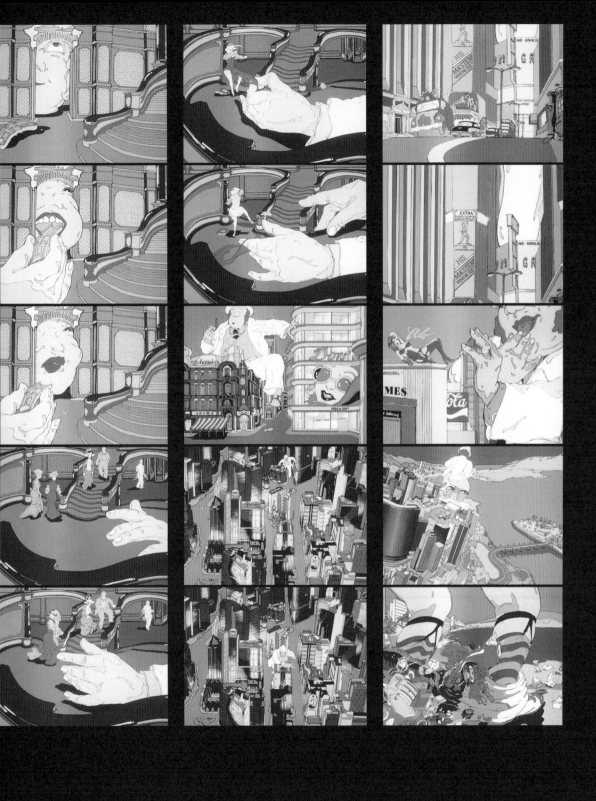

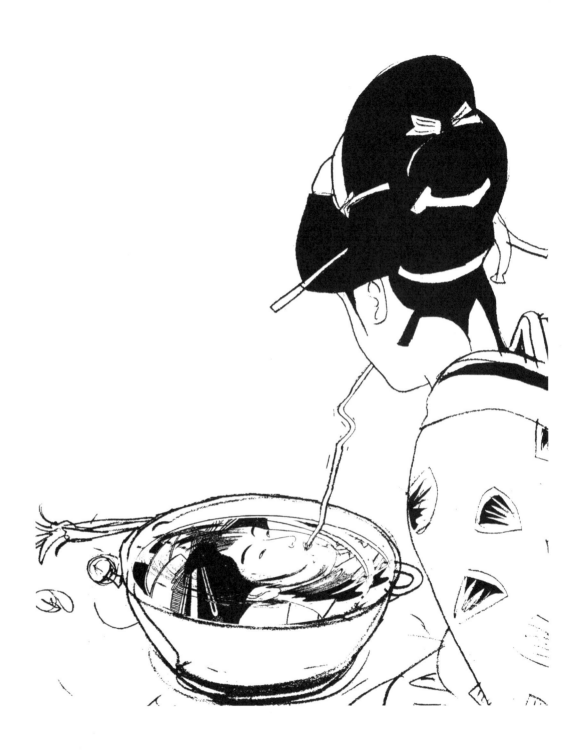

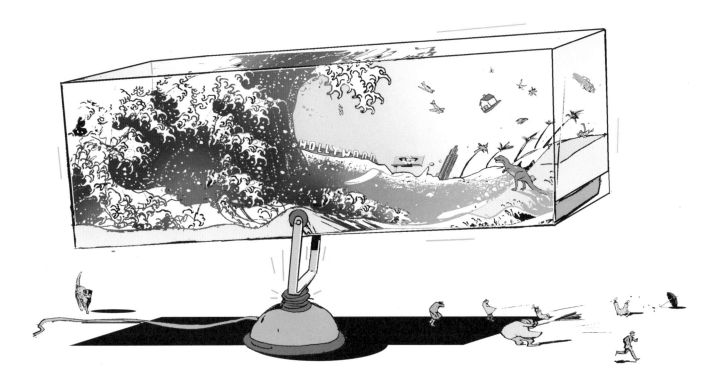

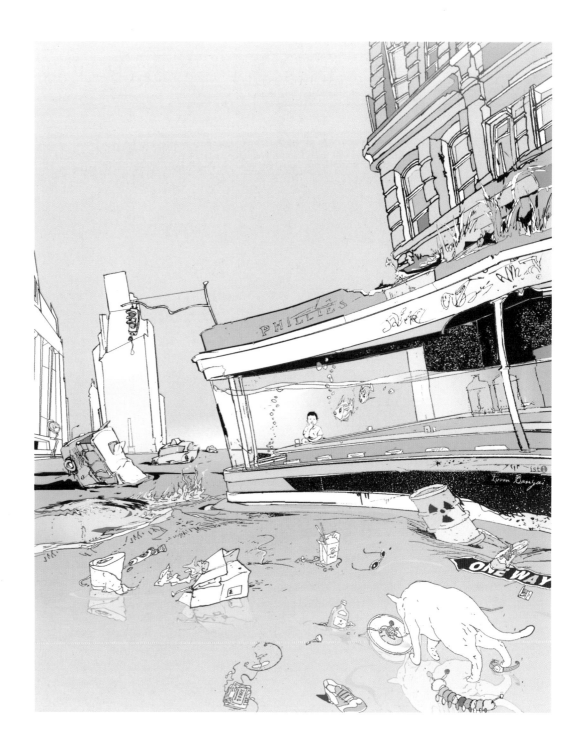

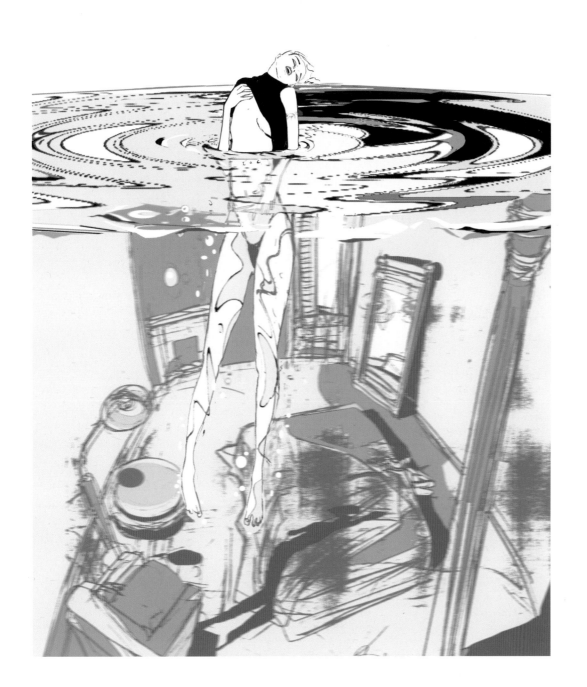

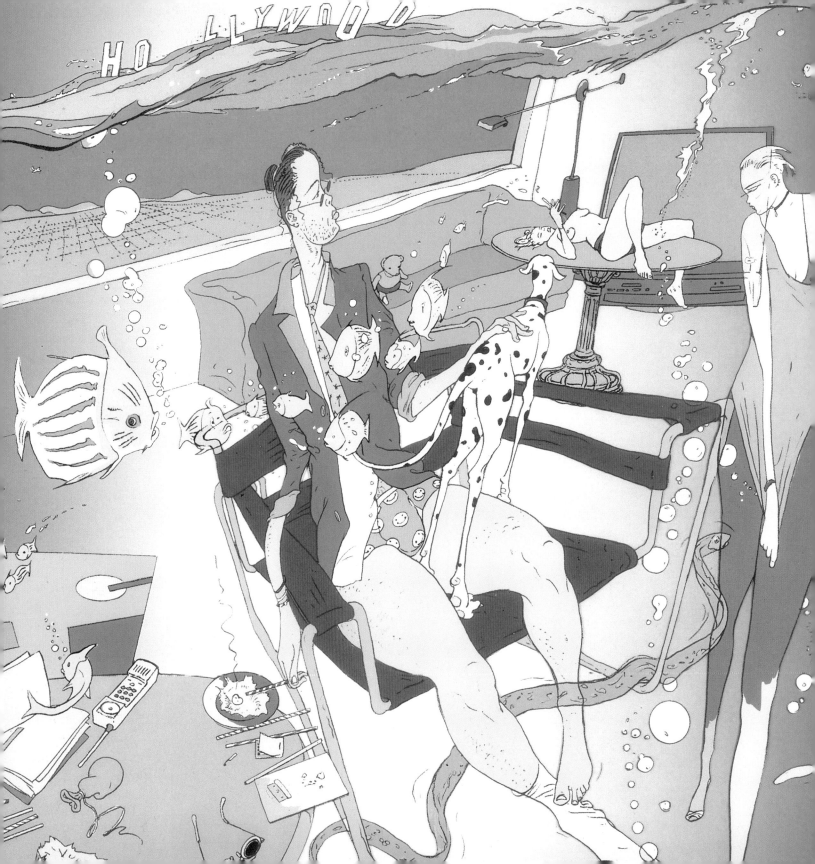

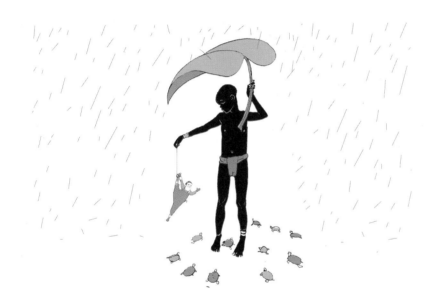

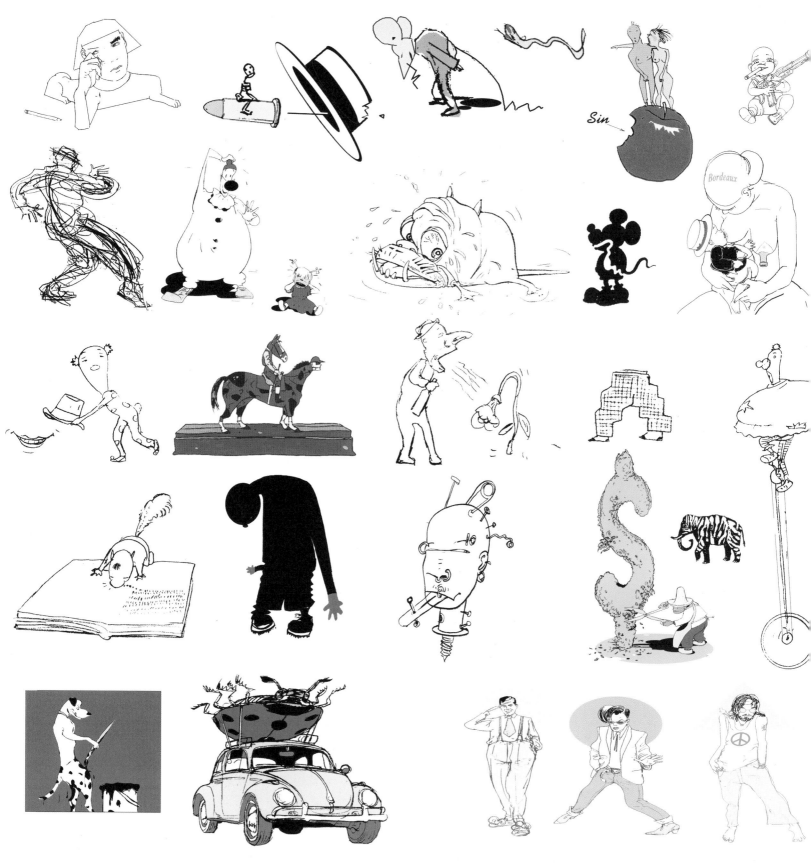

Sin

Bordeaux

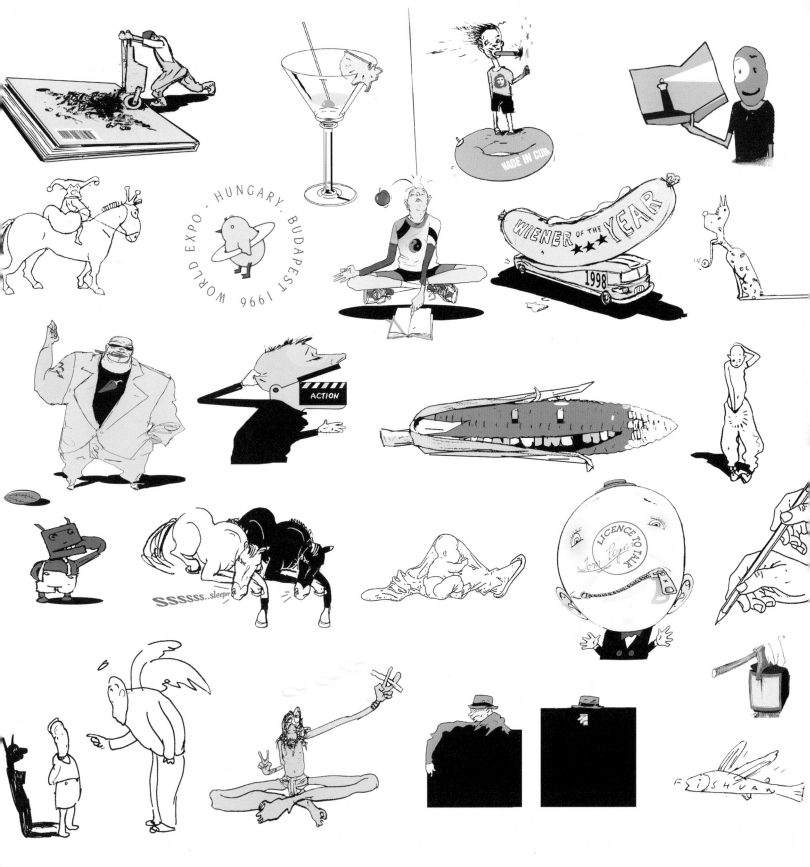

WORLD EXPO · HUNGARY, BUDAPEST 1996

WIENER OF THE YEAR ★★★ 1998

ACTION

SSSSSS...sleeper

LICENCE TO TALK

FISHVAN

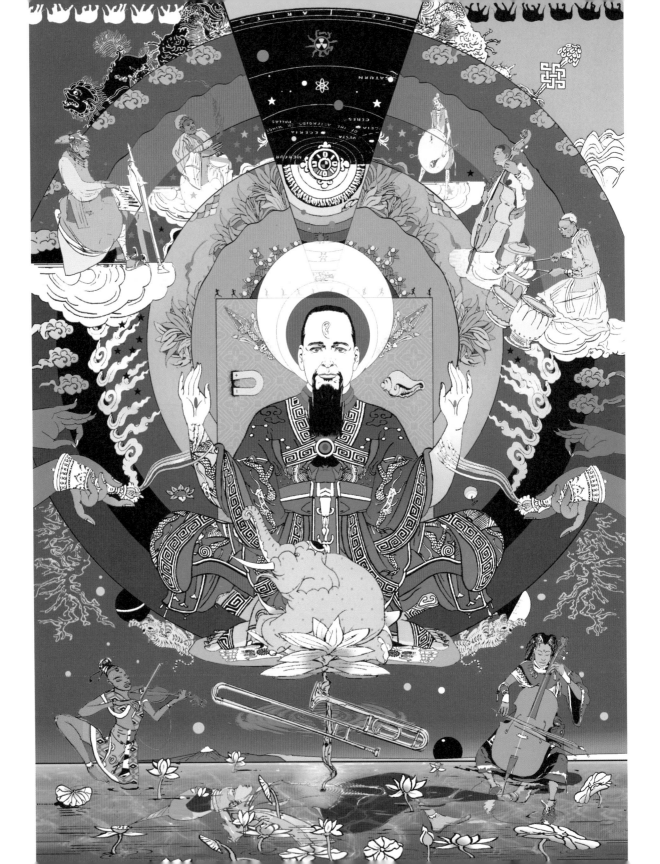

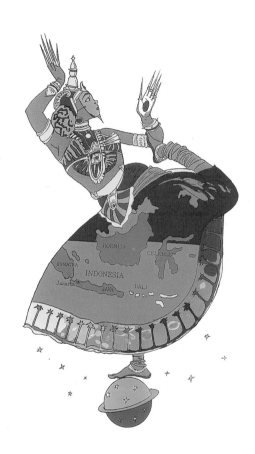

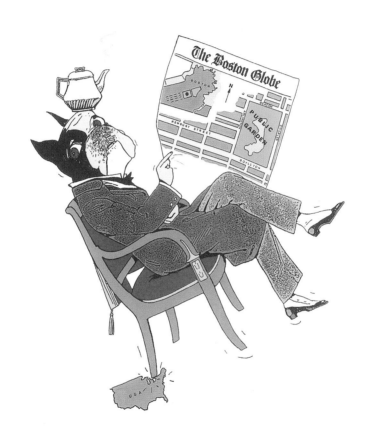

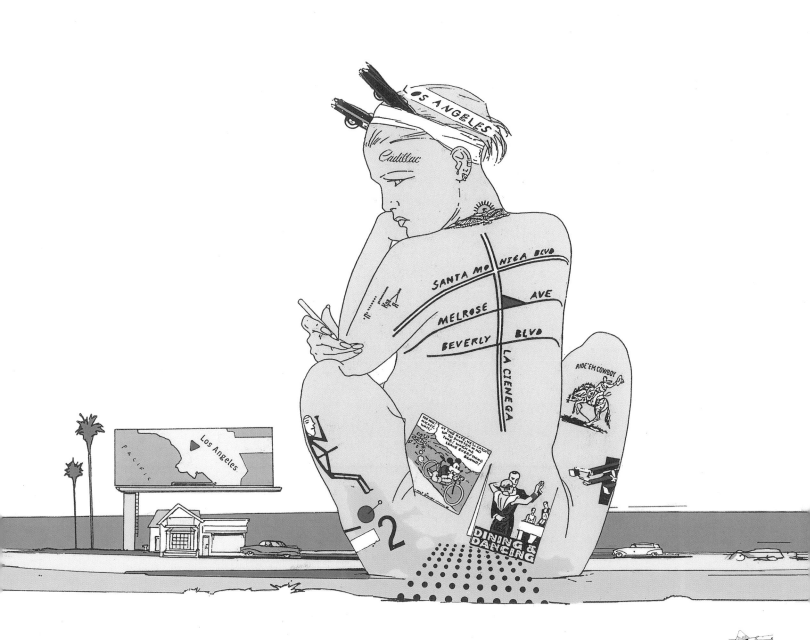

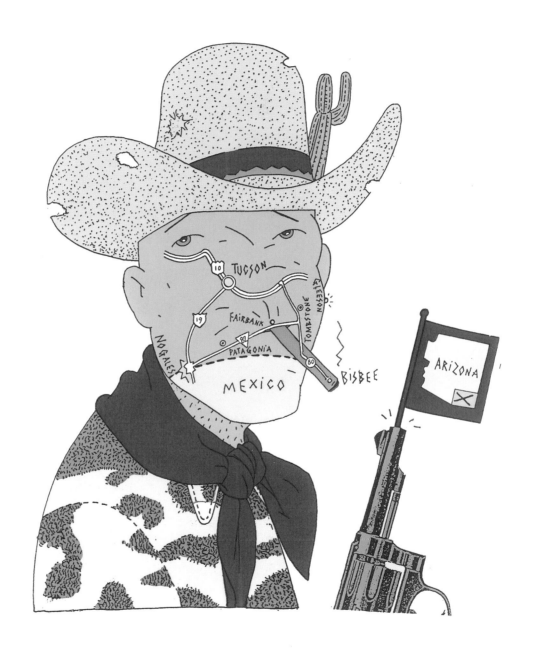

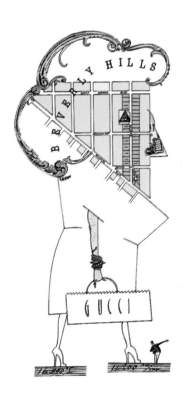

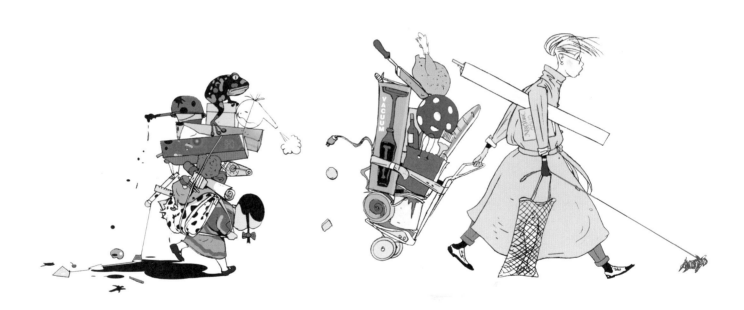

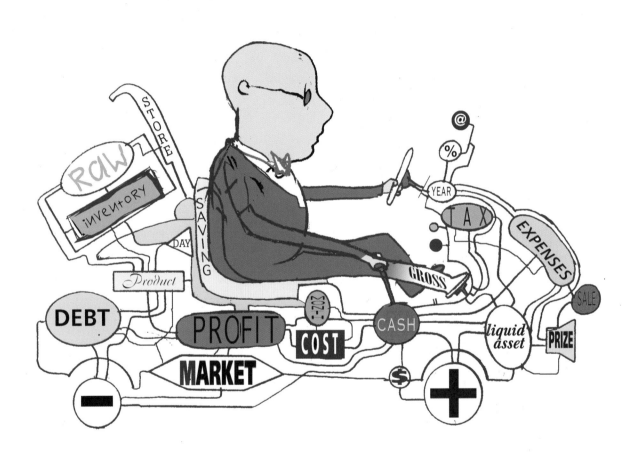

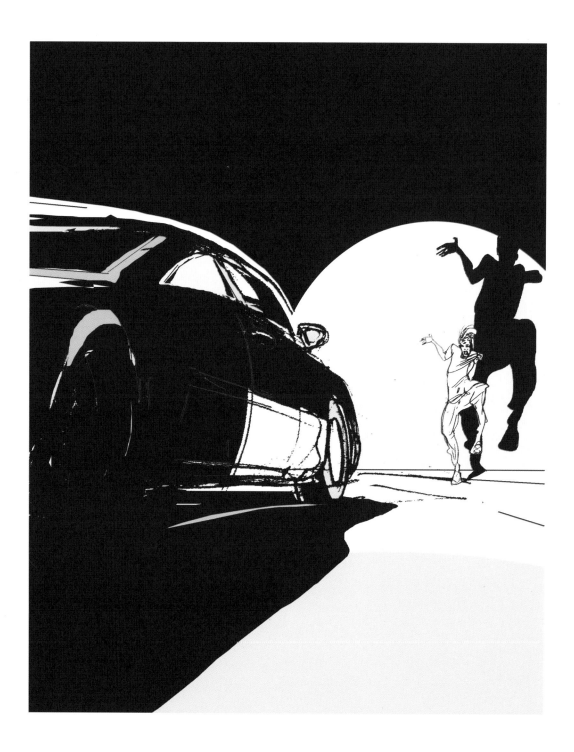

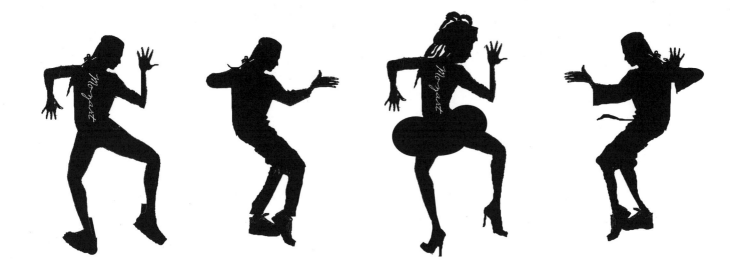

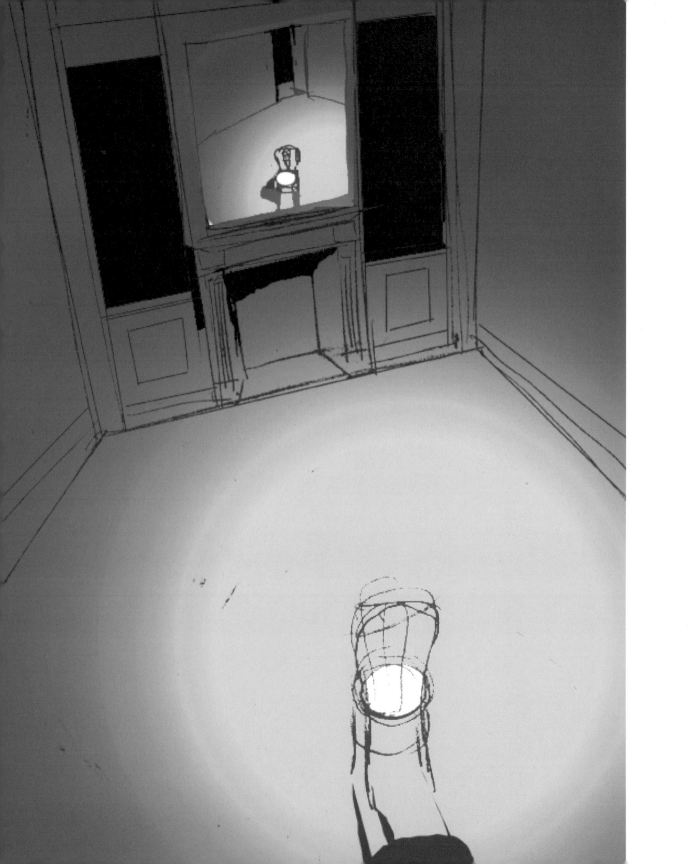

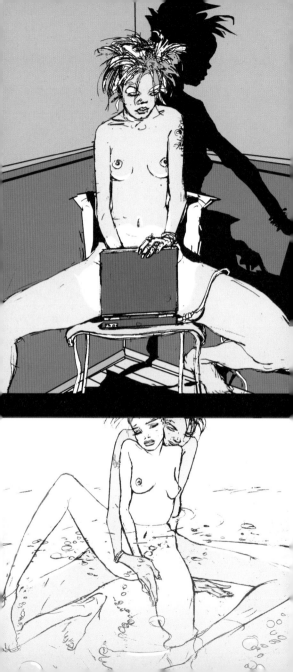

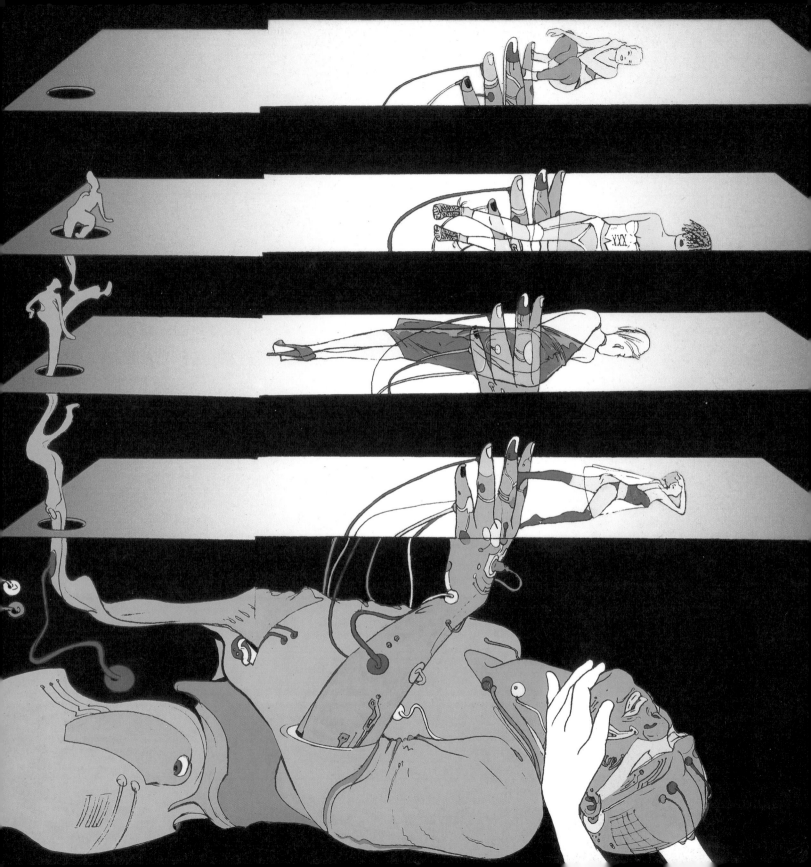

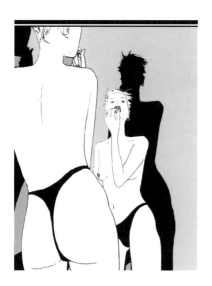
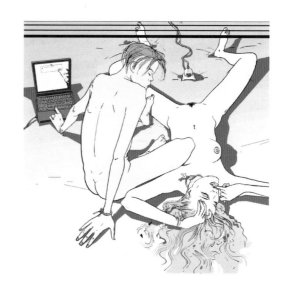

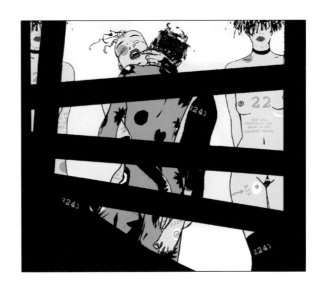

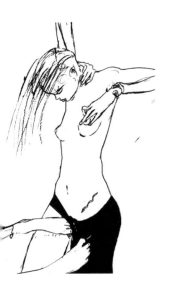

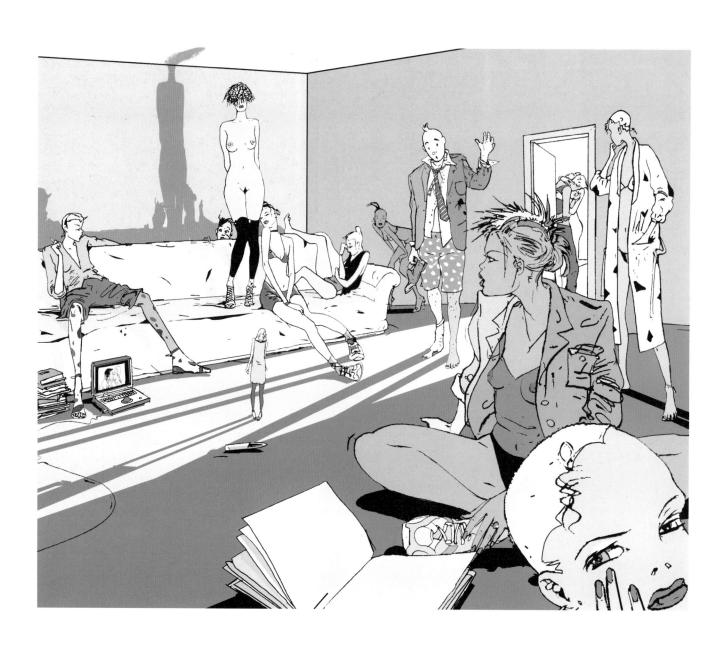

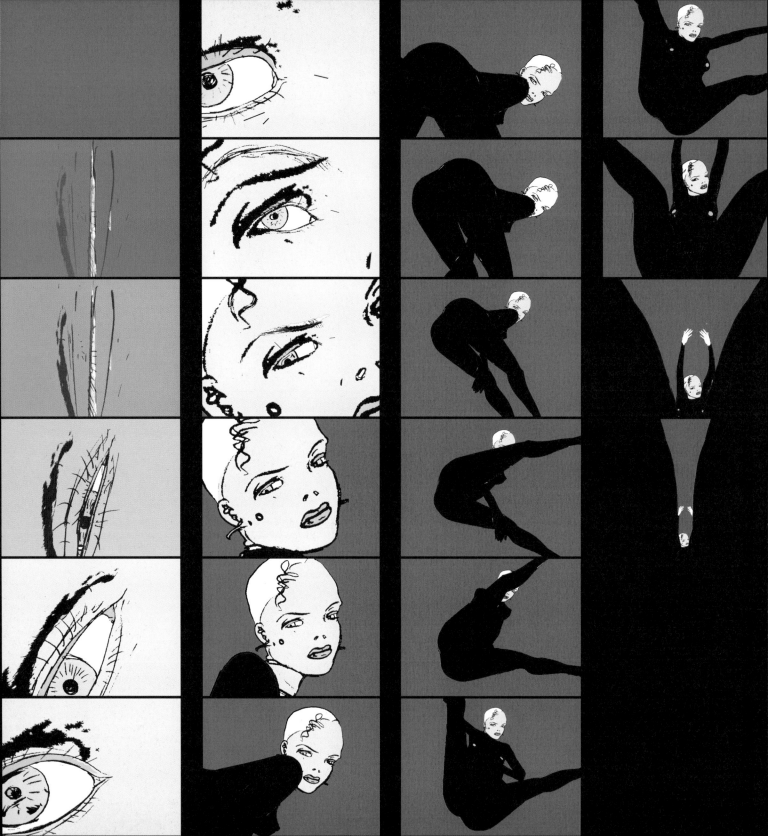

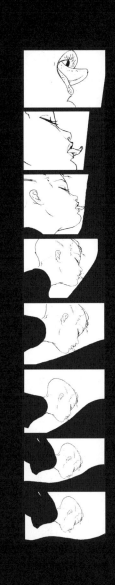

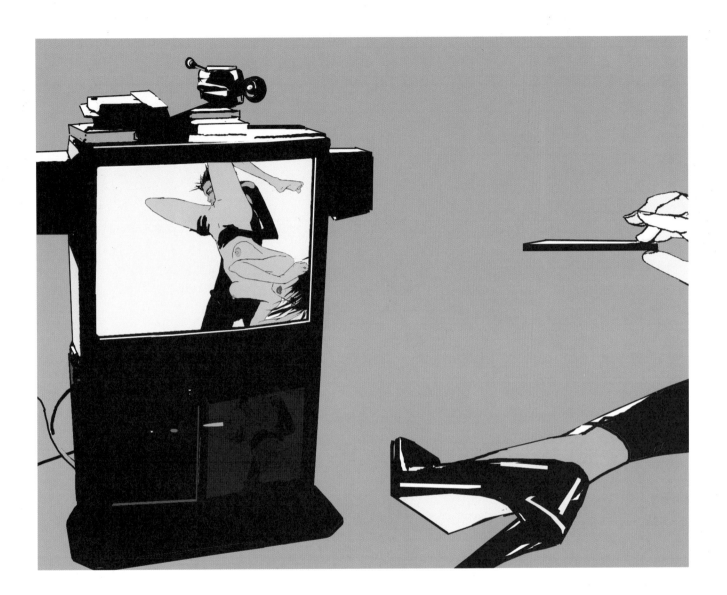

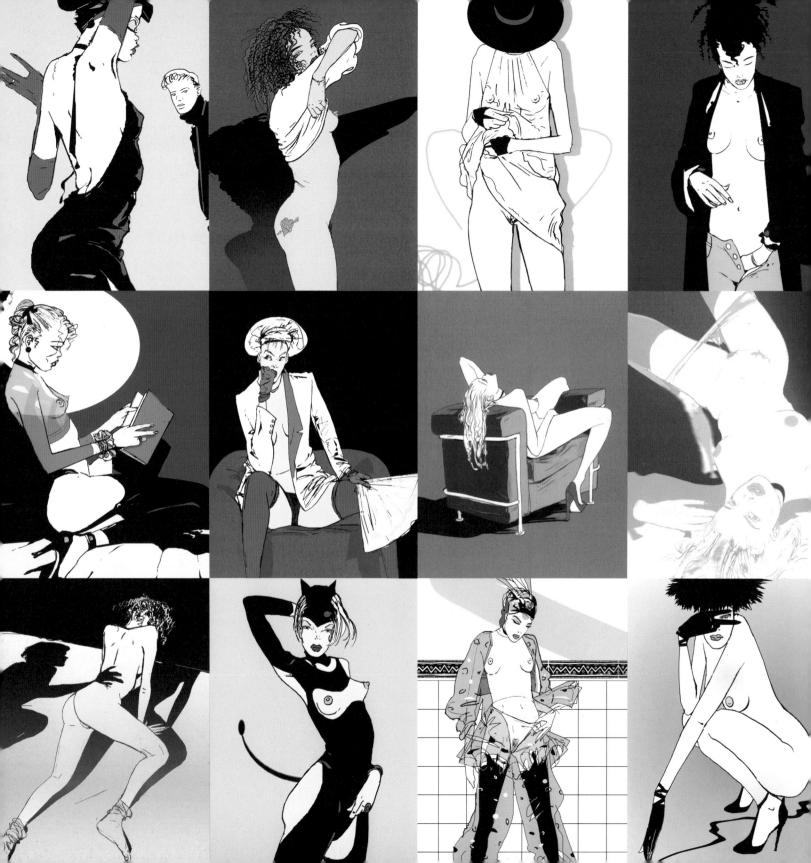

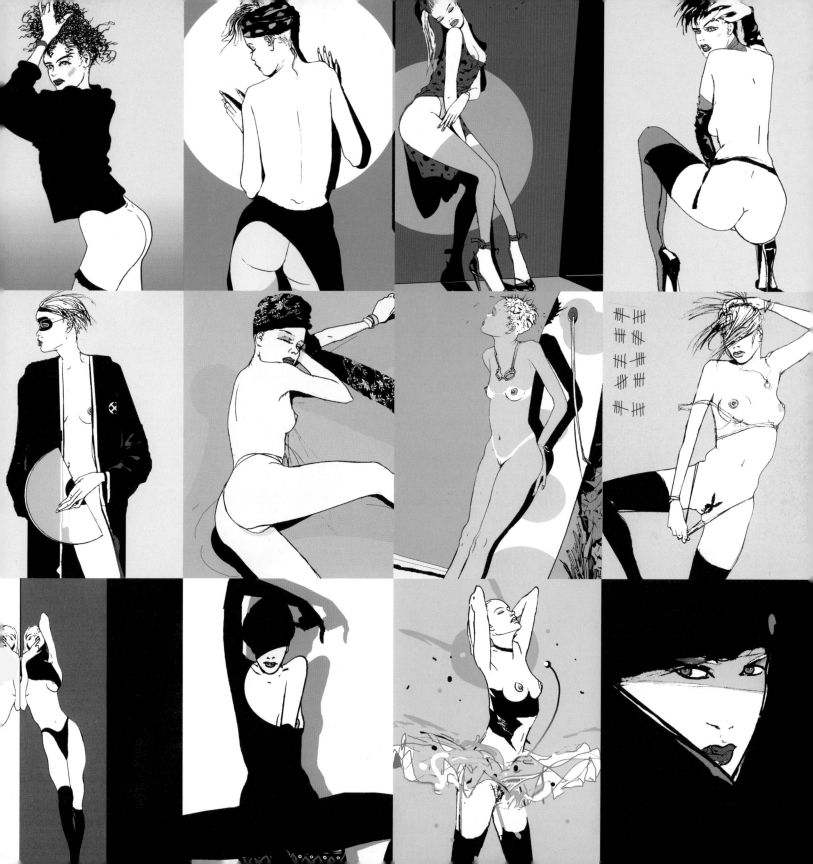

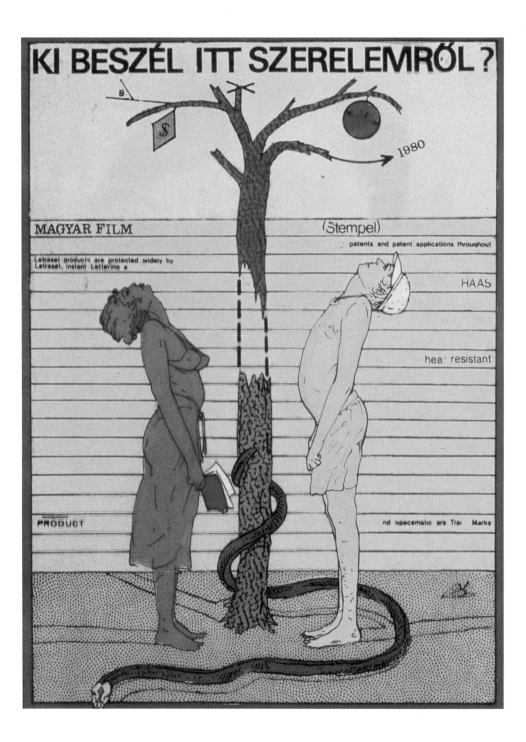

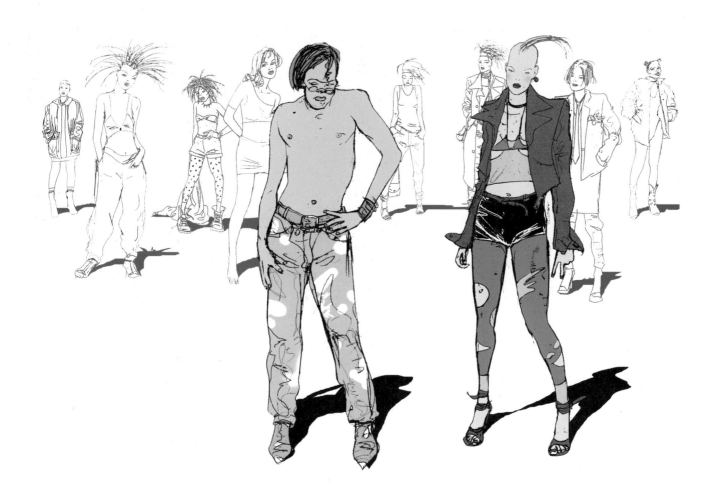

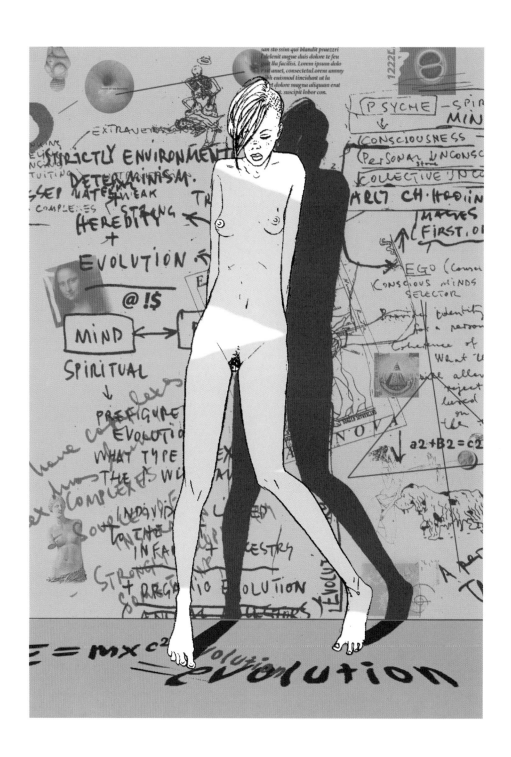

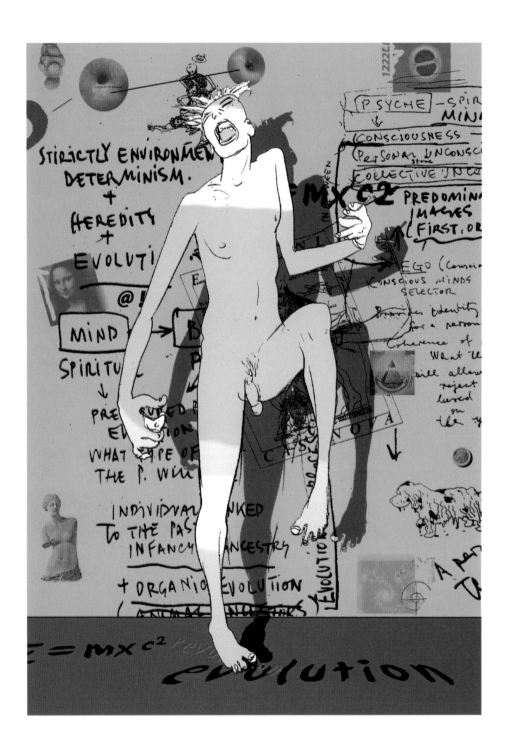

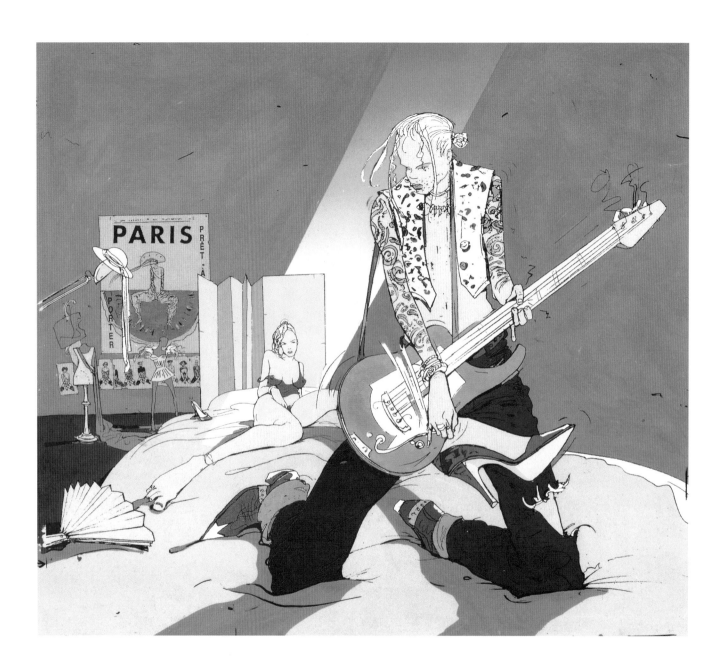

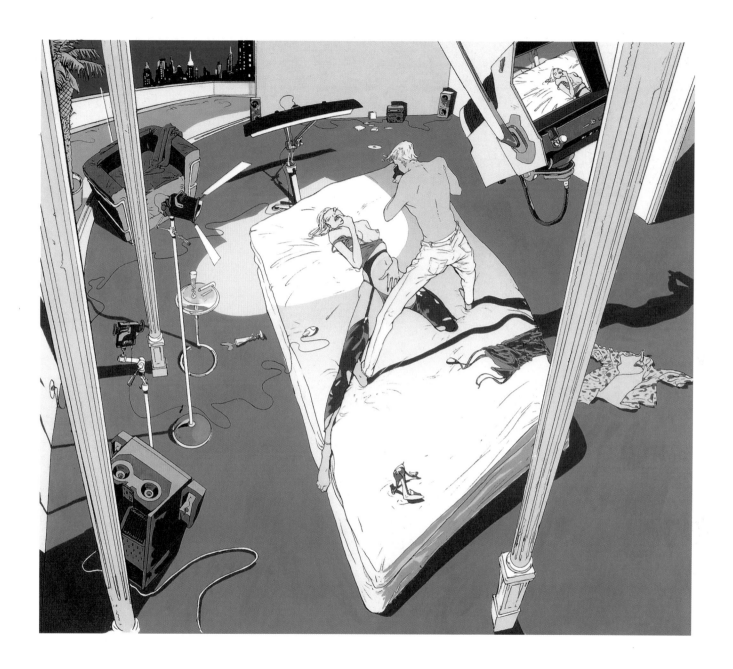

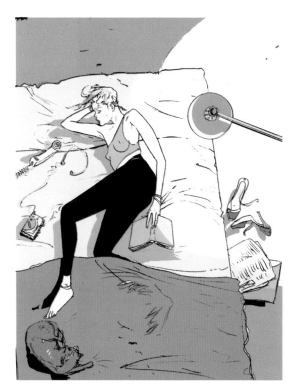
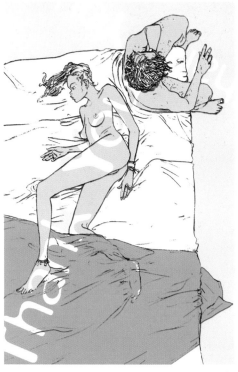

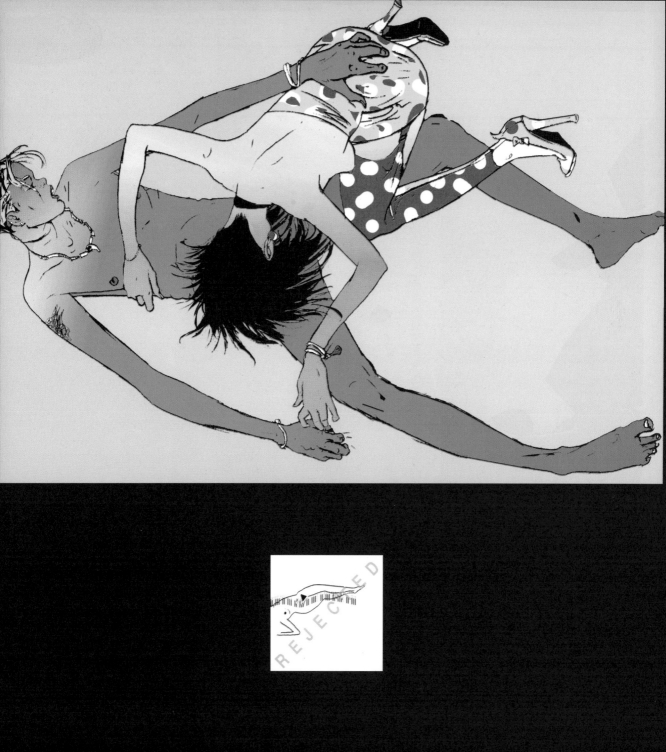

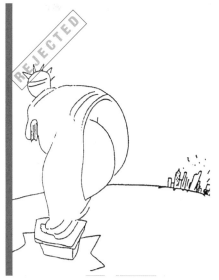

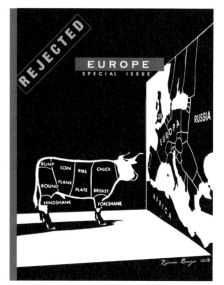

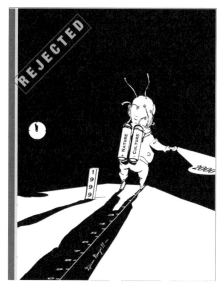

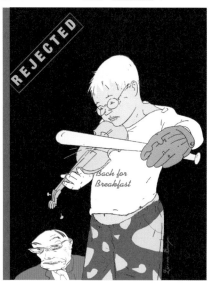

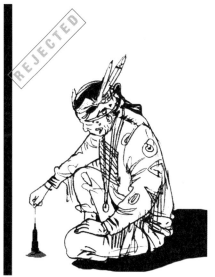

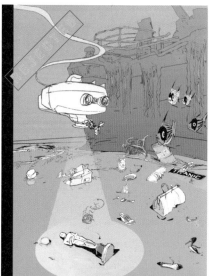

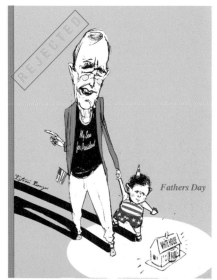

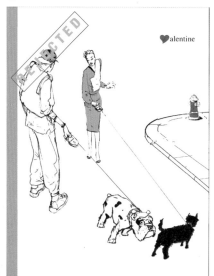

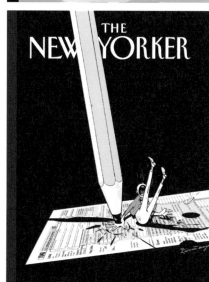

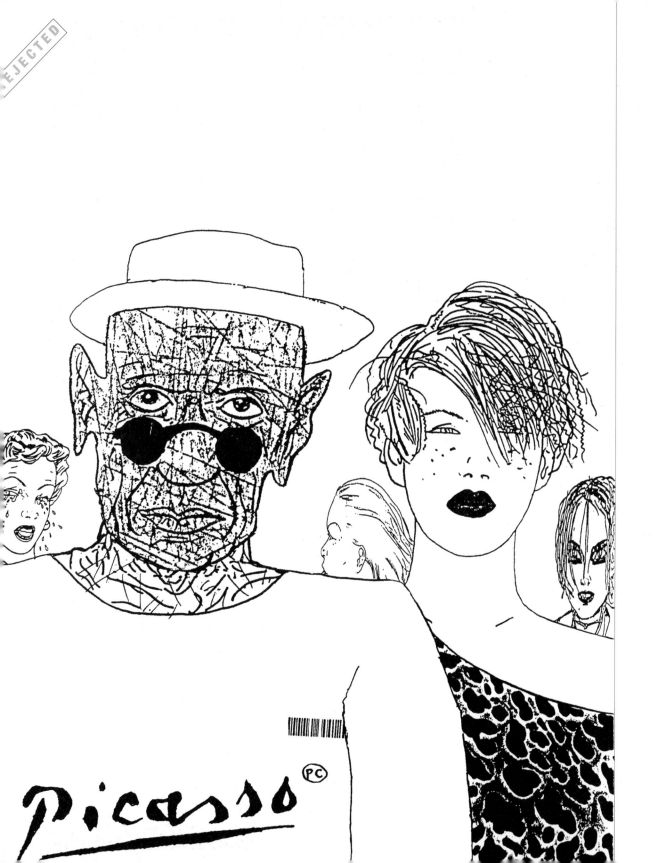

Picasso ®

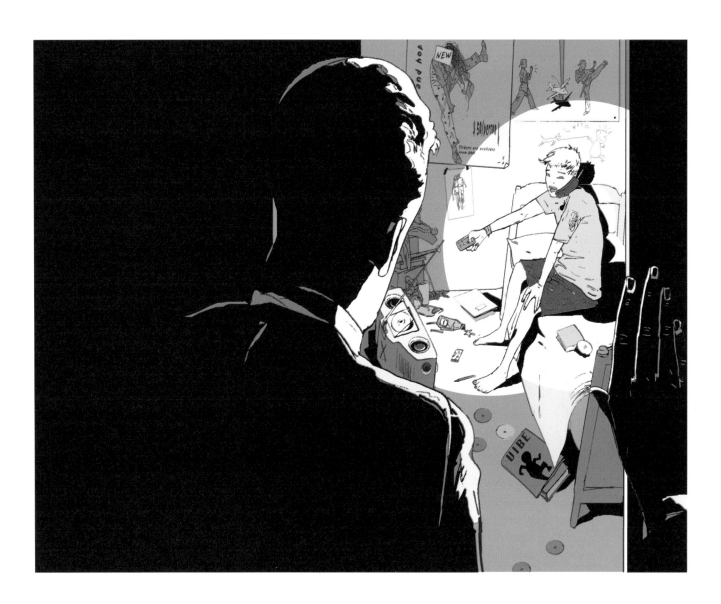

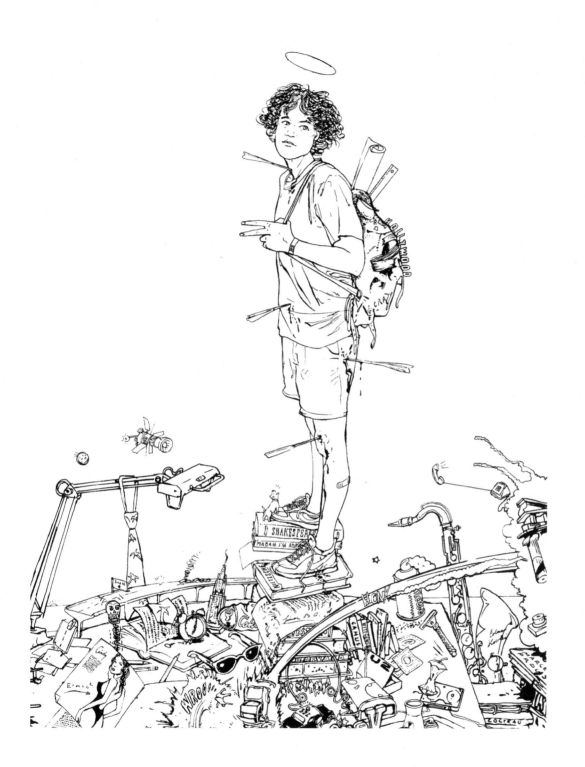

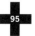

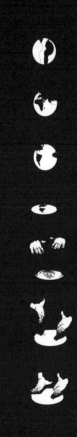

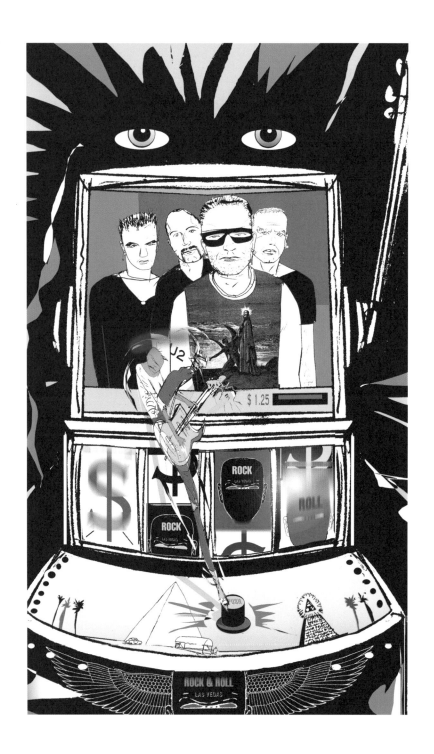

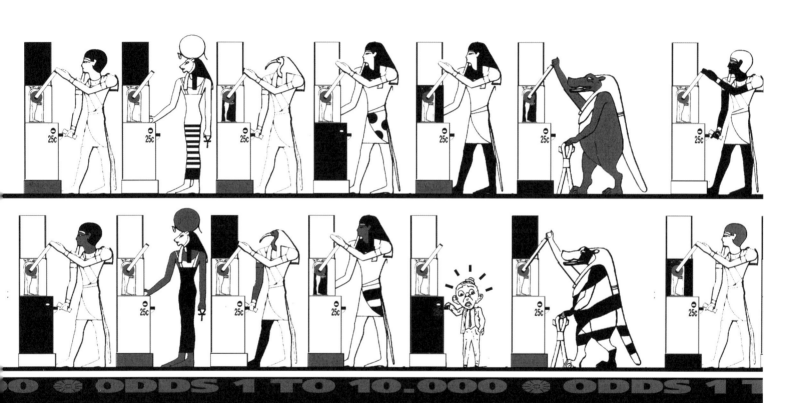

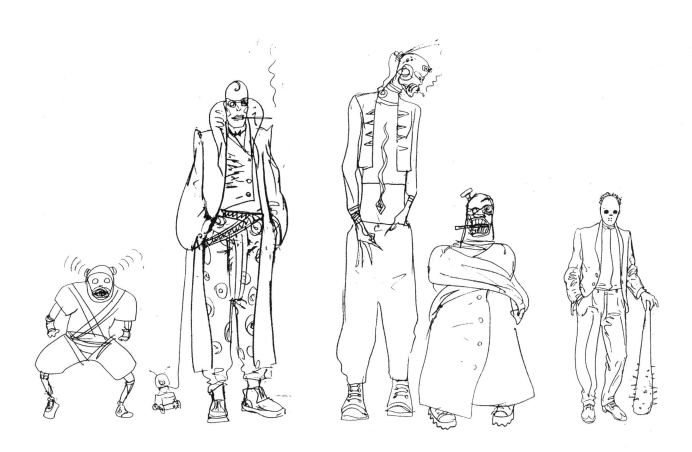

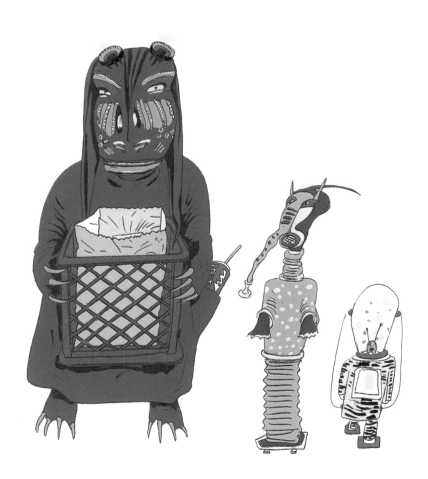
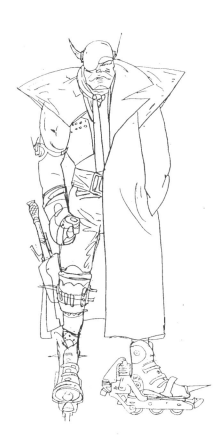

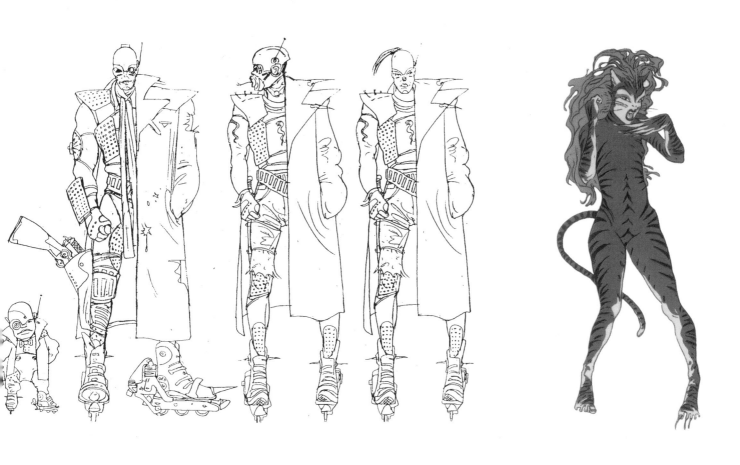

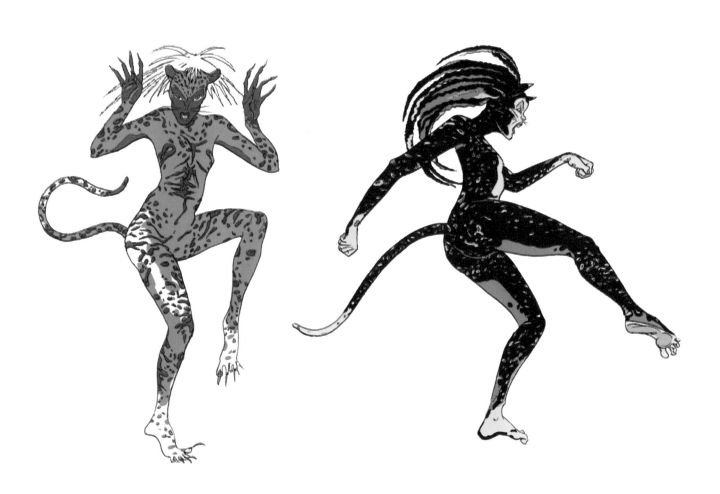

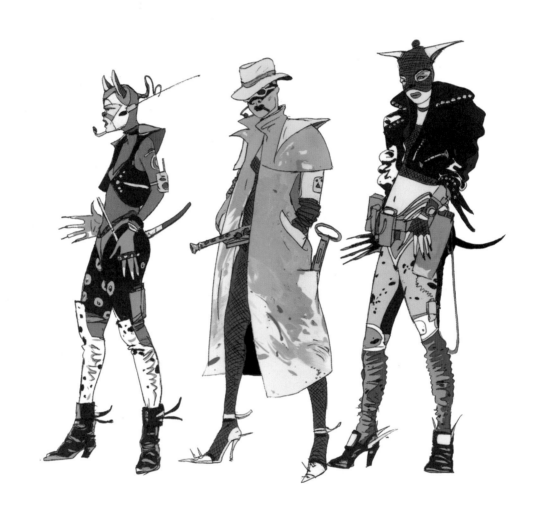

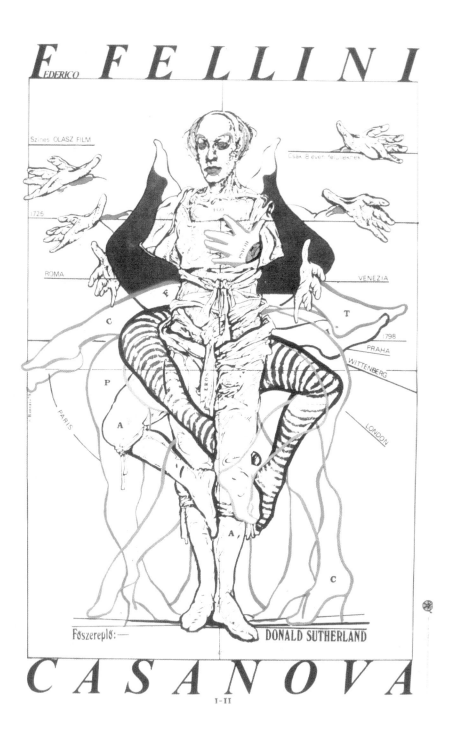

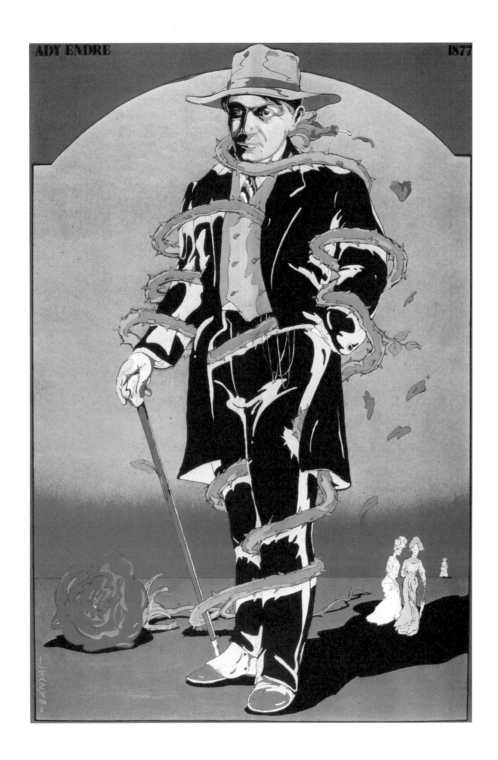

ADY ENDRE 1877

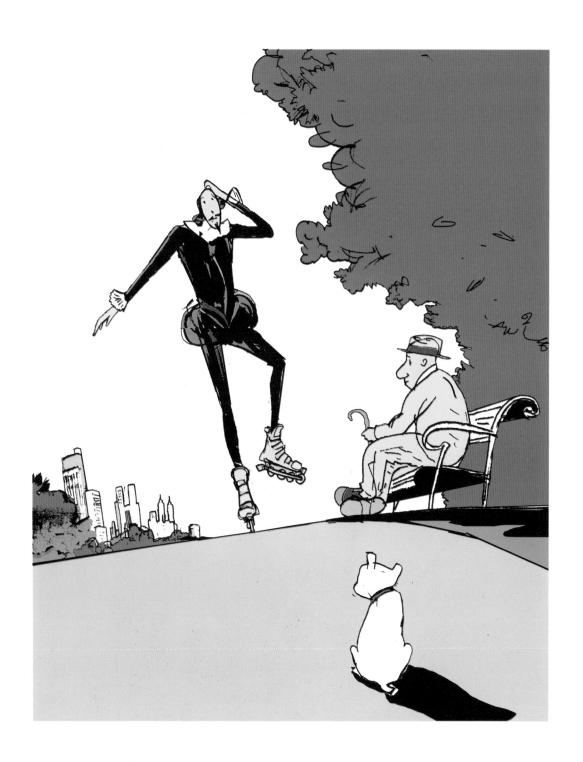

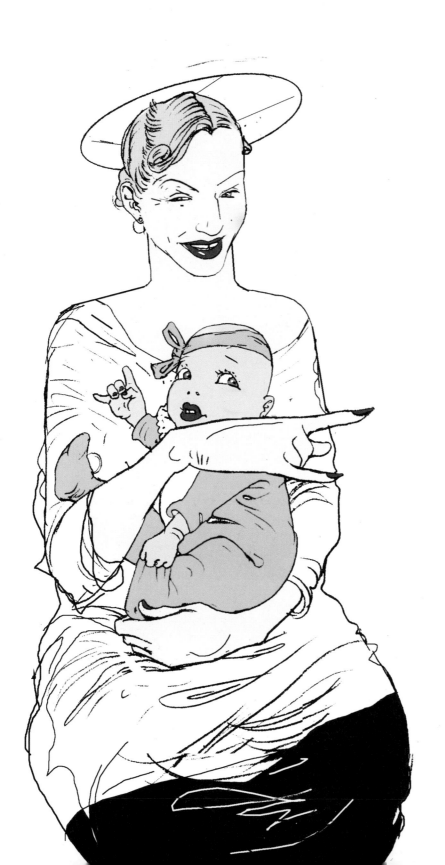

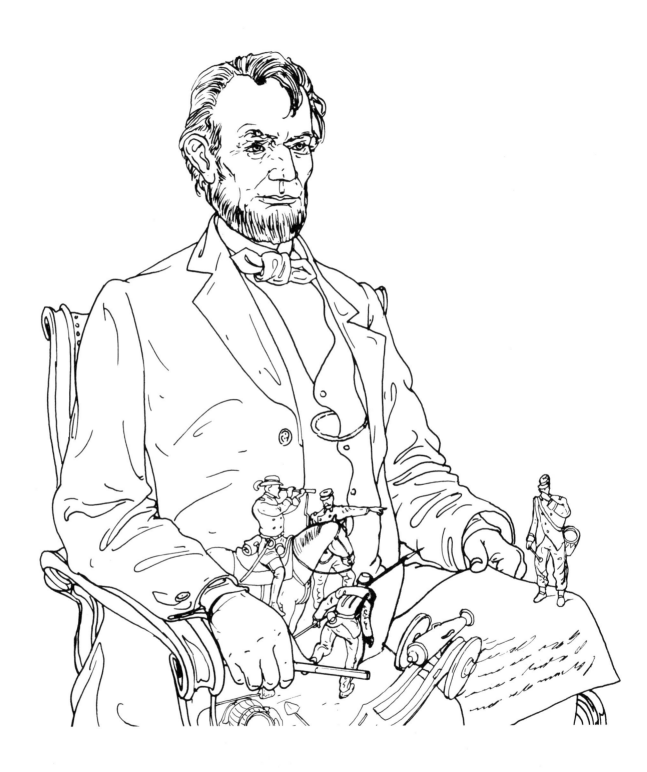

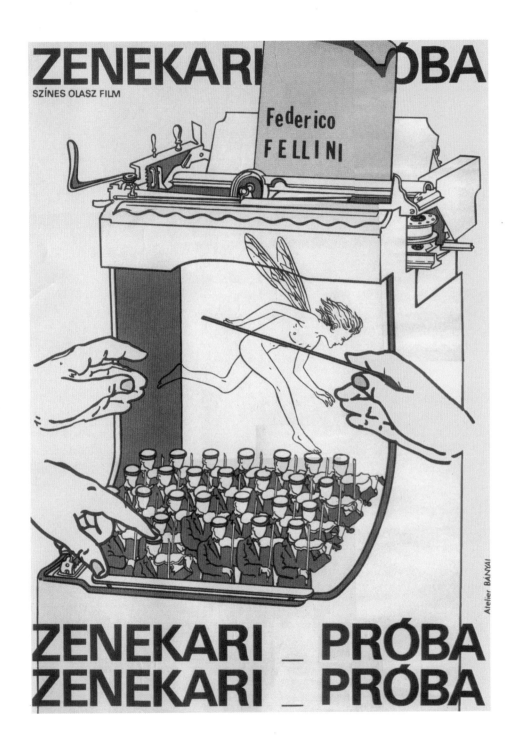

ZENEKARI PRÓBA

SZÍNES OLASZ FILM

Federico FELLINI

Atelier BÁNYAI

ZENEKARI — PRÓBA

ZENEKARI — PRÓBA

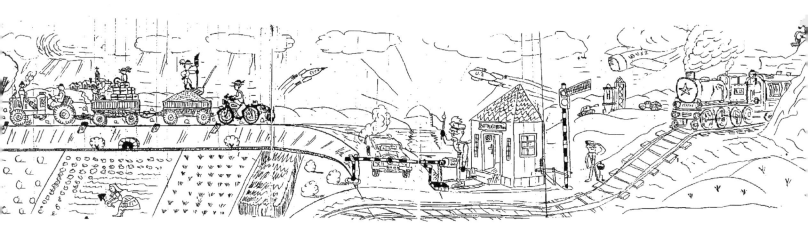

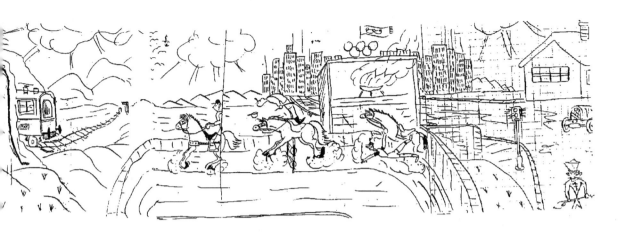

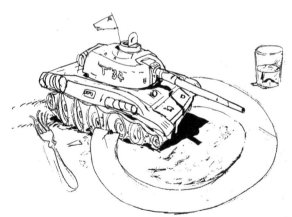

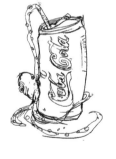

békeharc

113

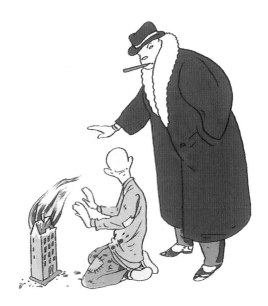

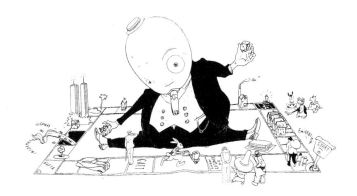

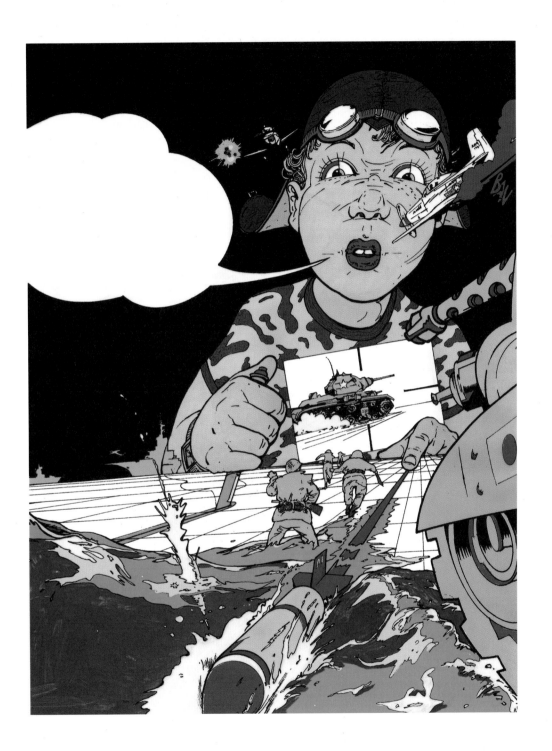
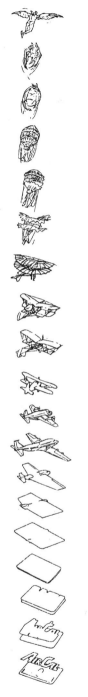
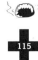

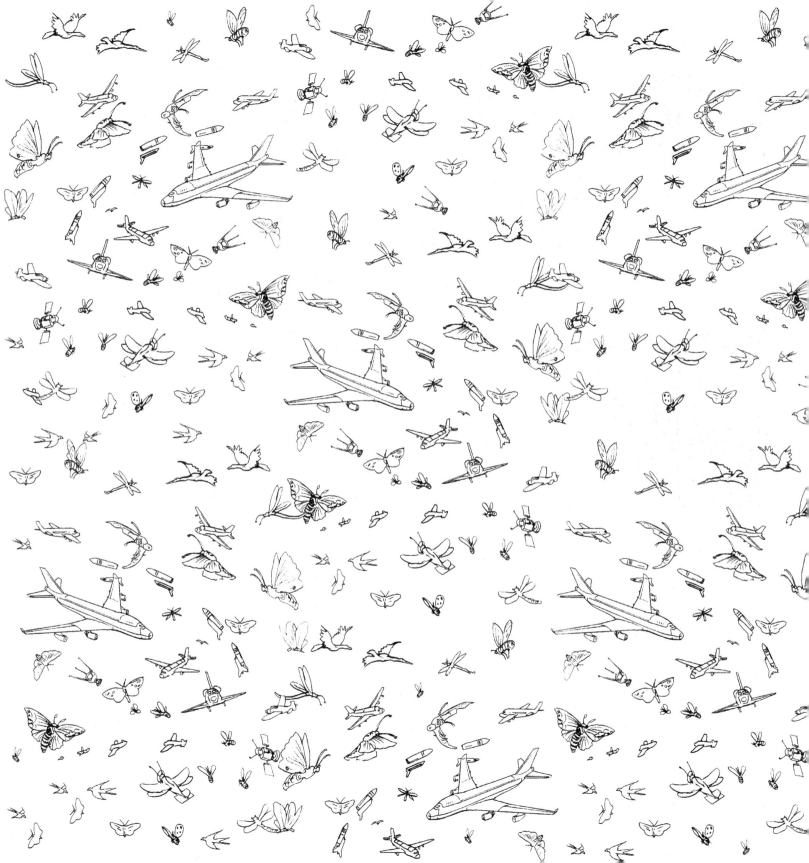

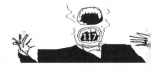

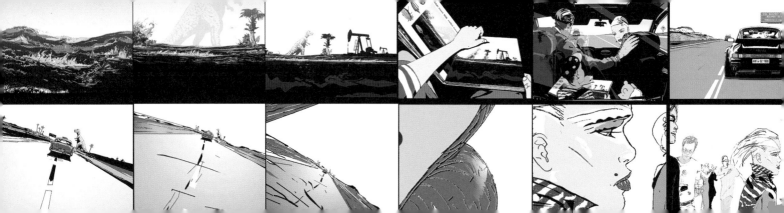

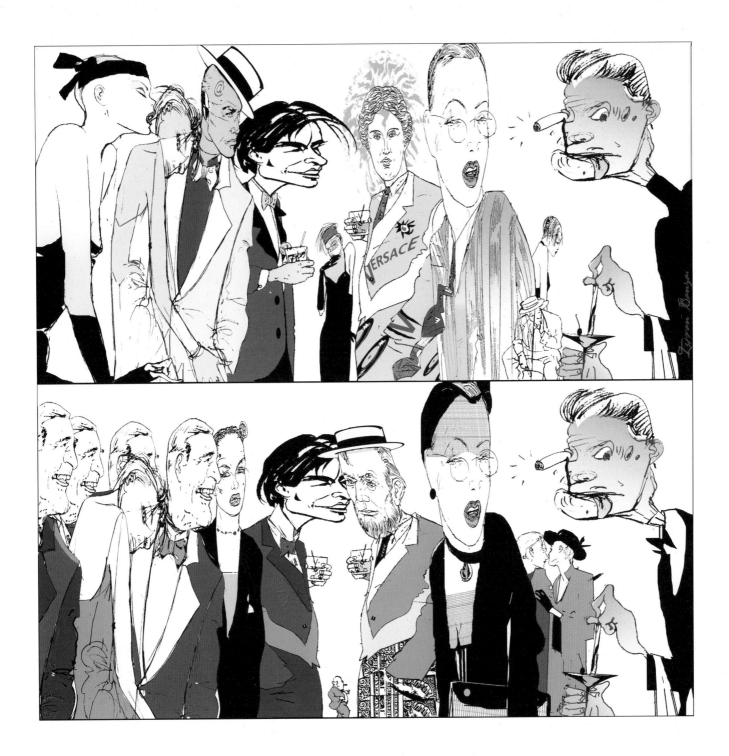

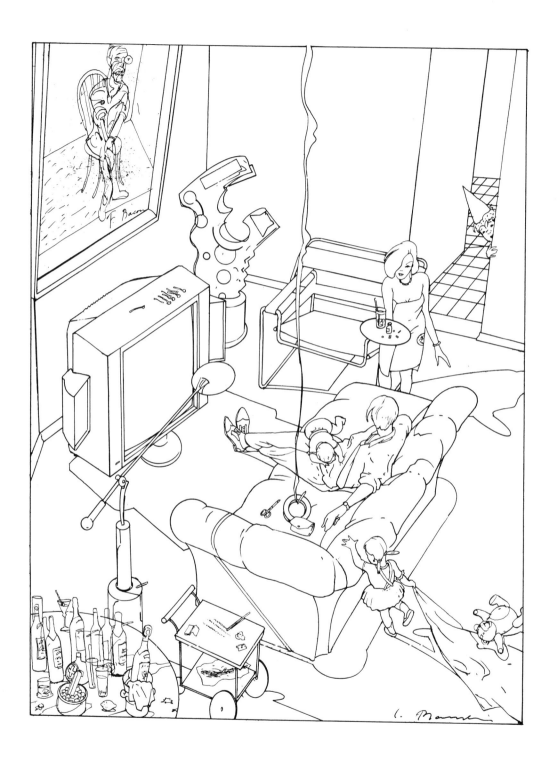

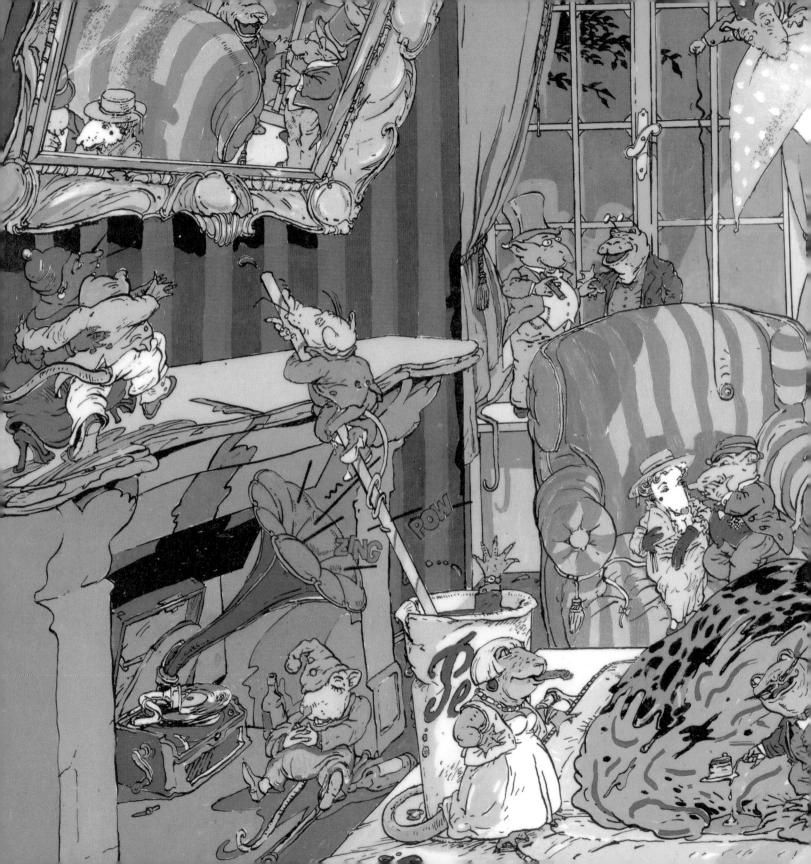

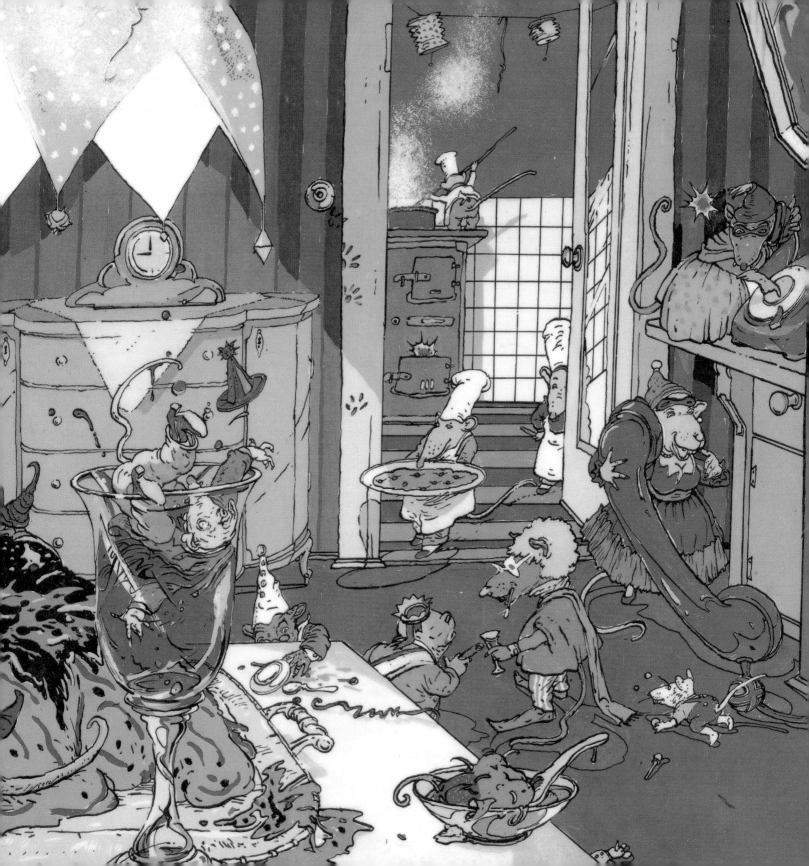

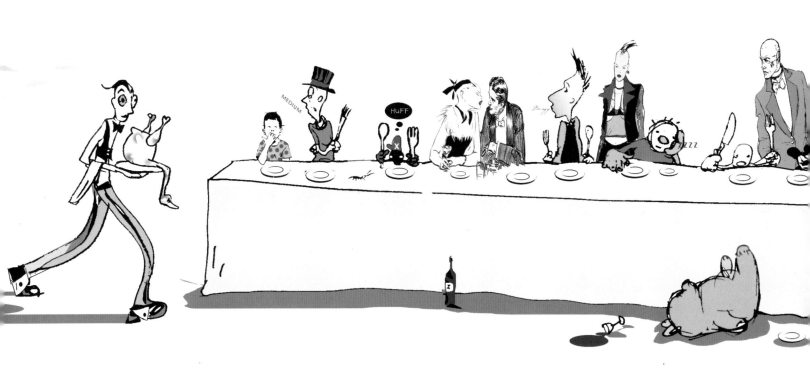

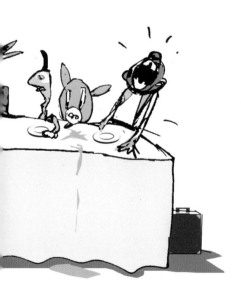

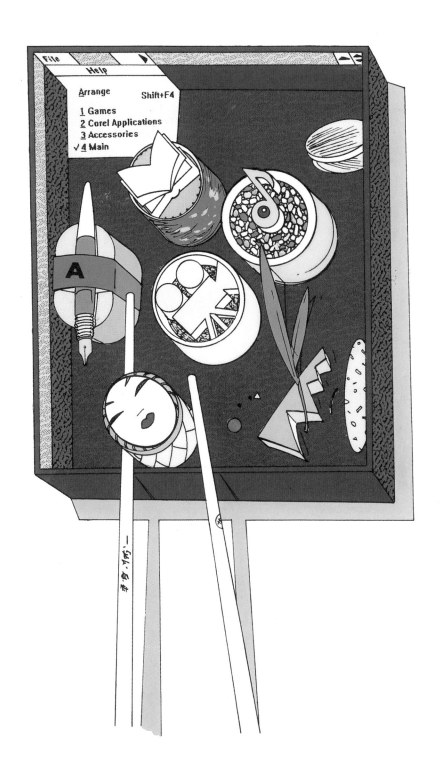

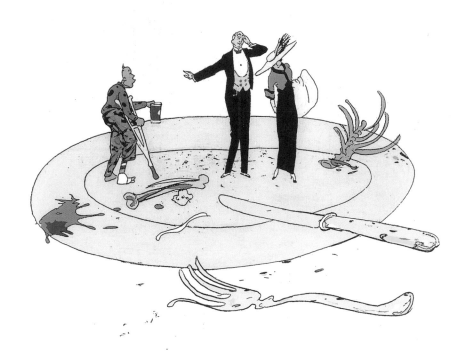

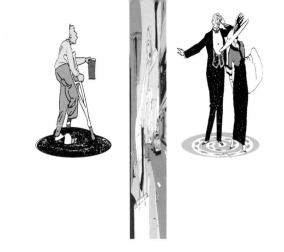

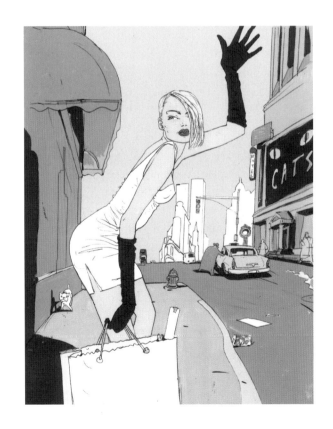

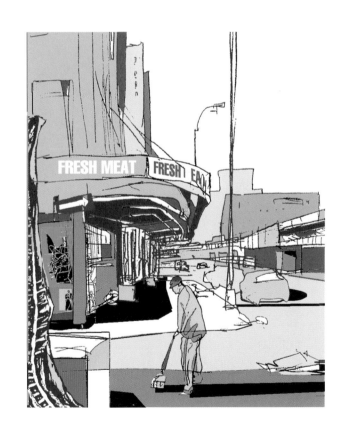

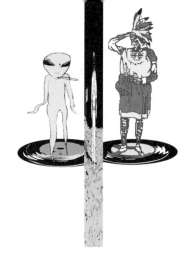

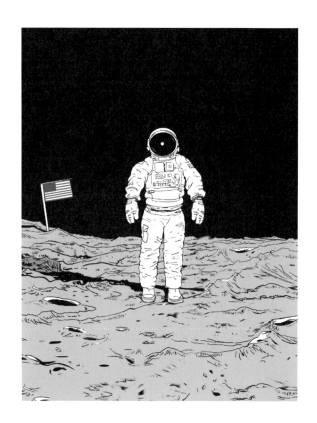

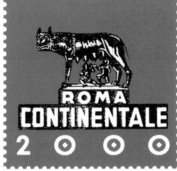

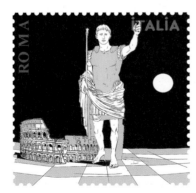

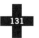

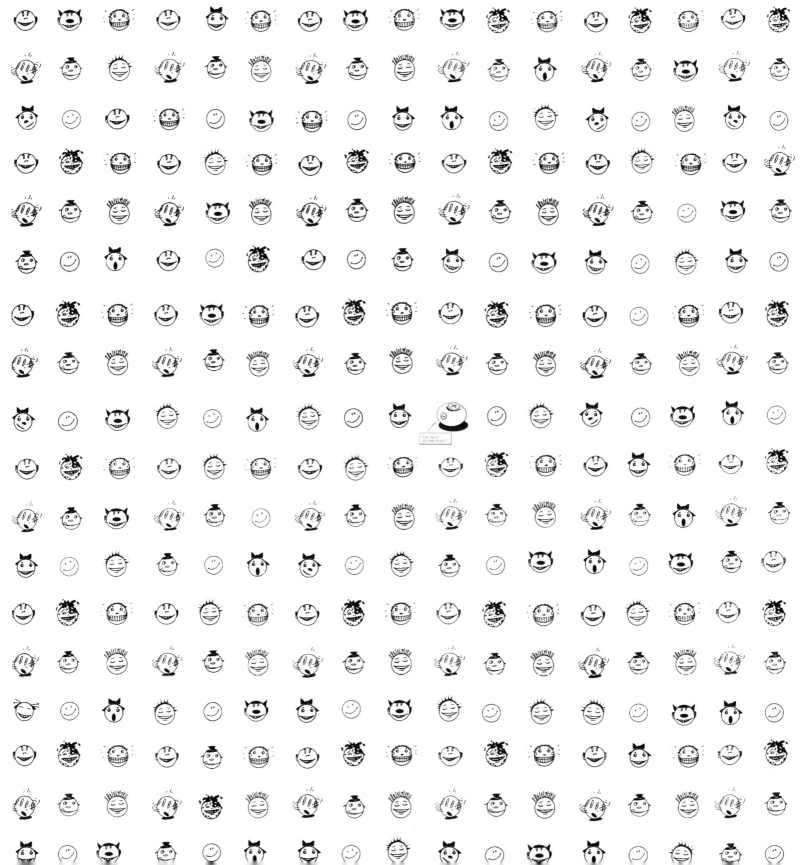

"Can I be of
any help to you?"

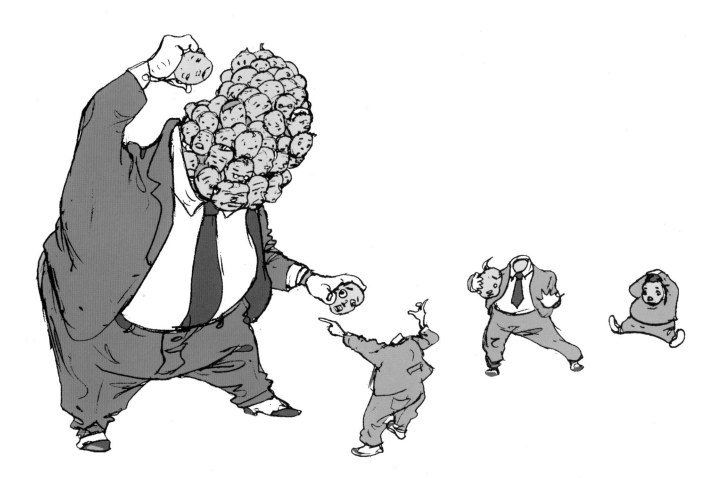

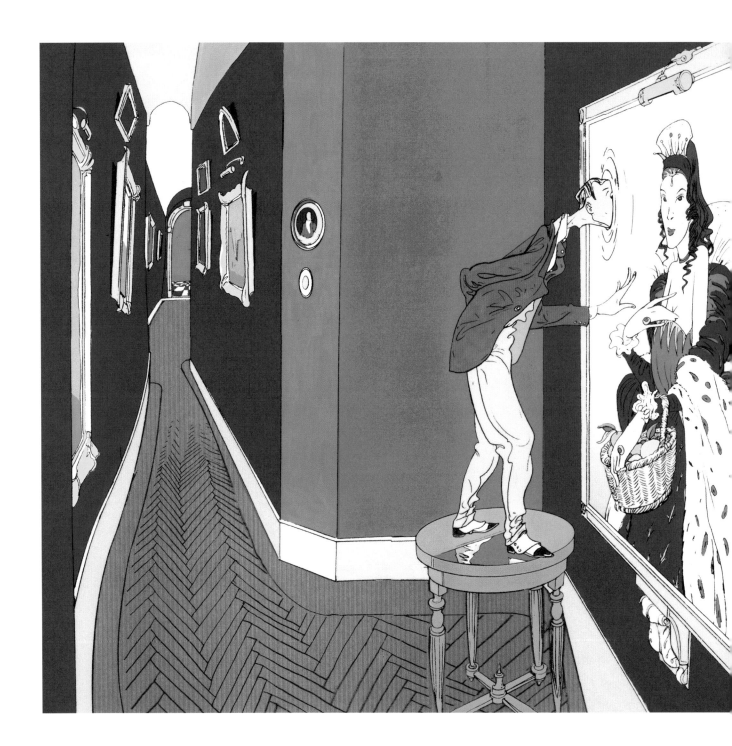

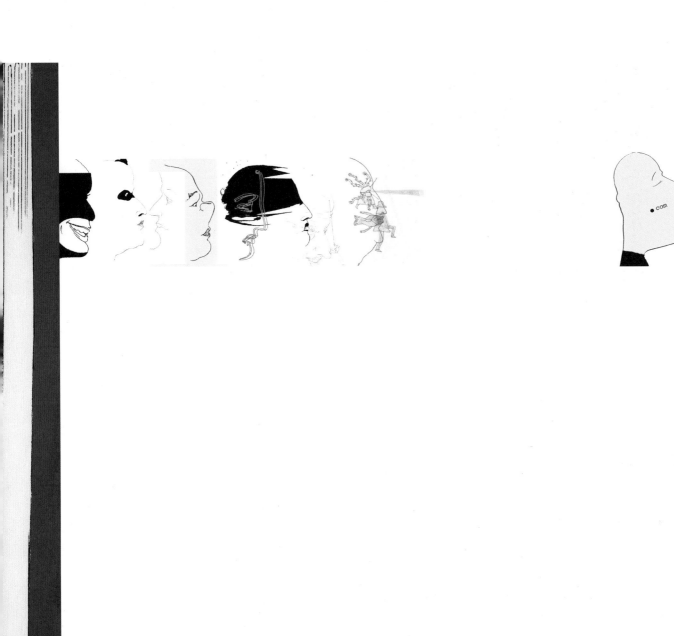

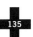

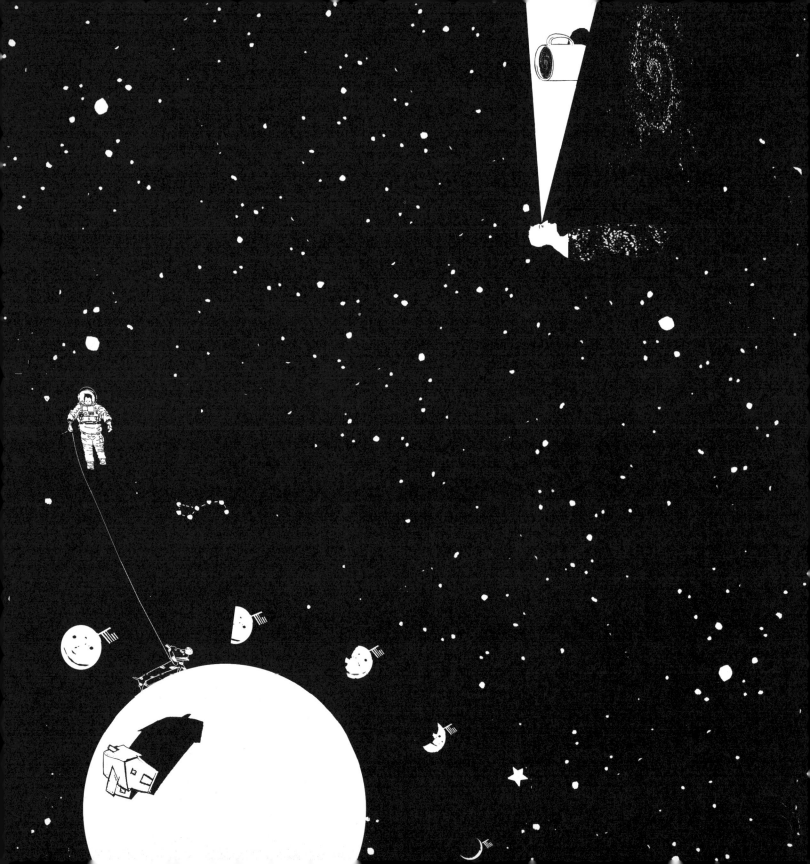

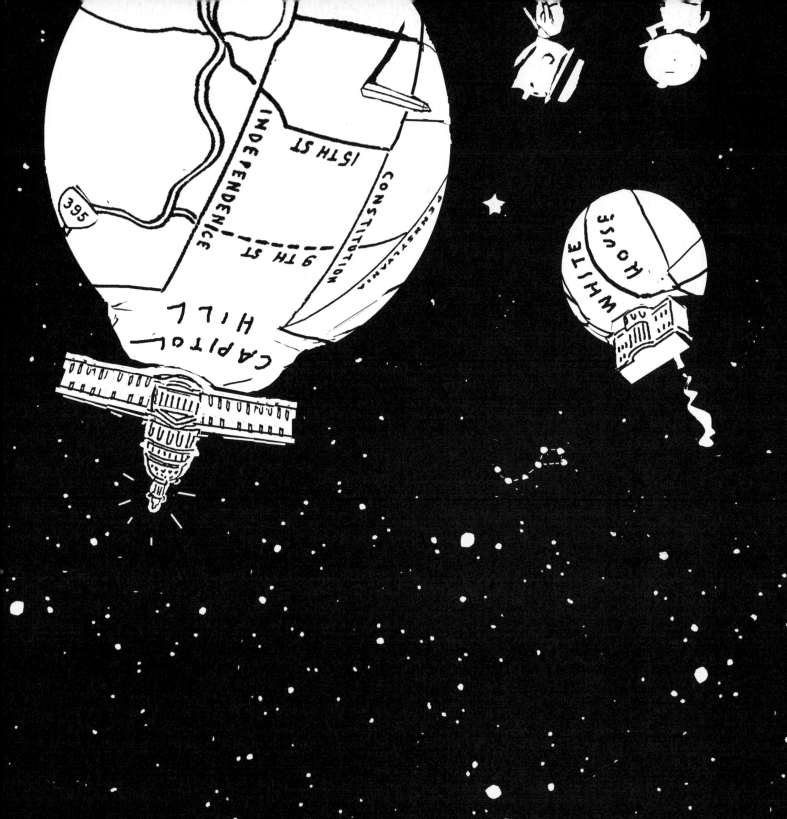

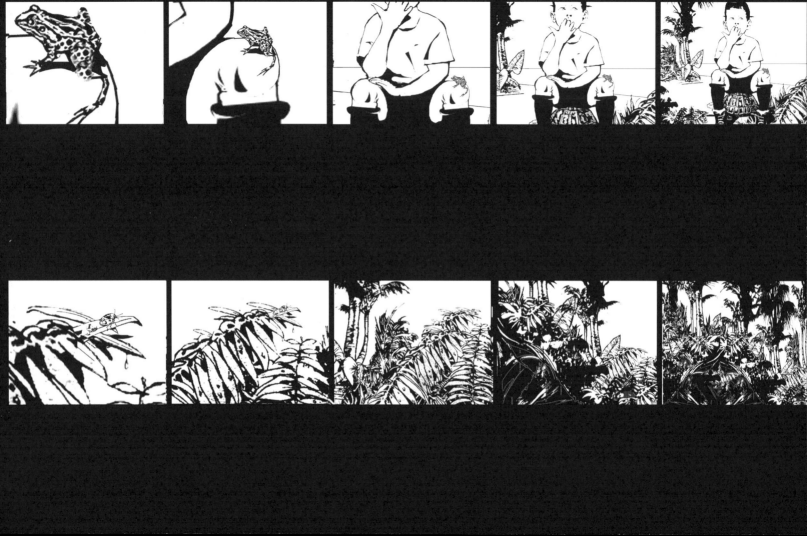

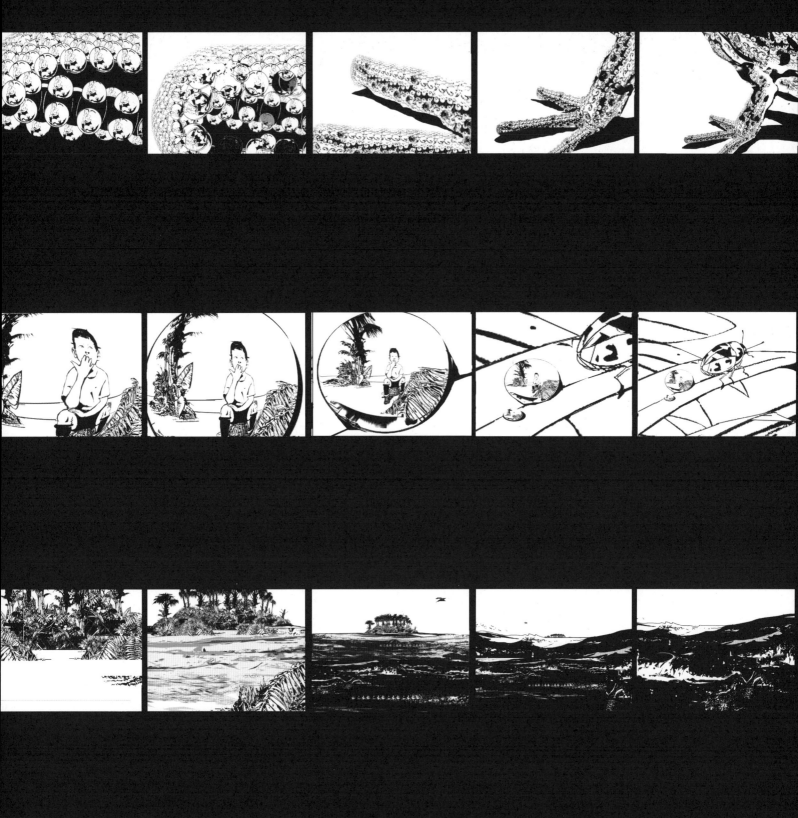

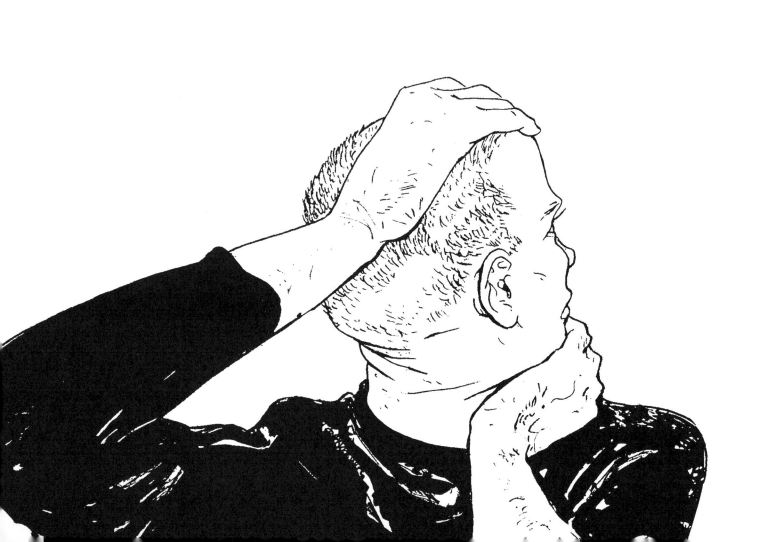

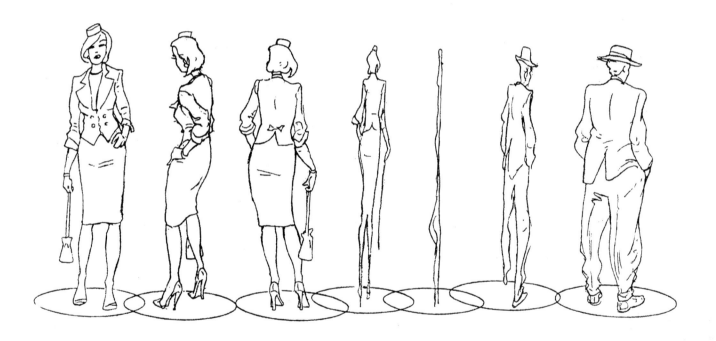

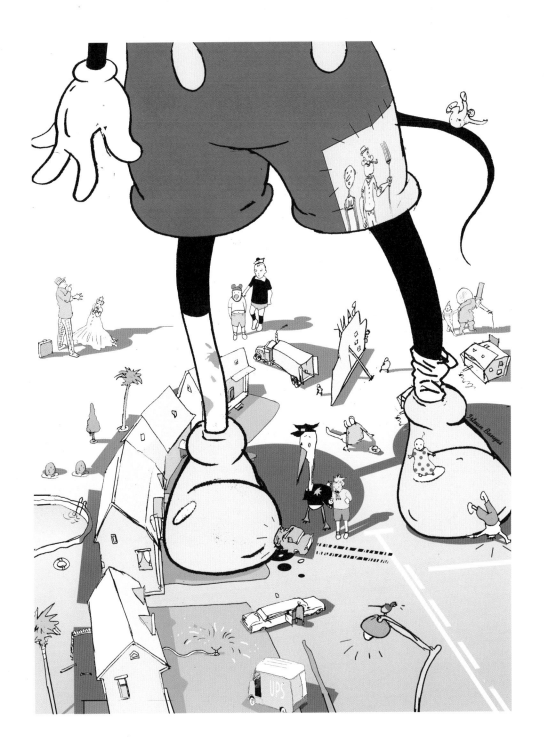

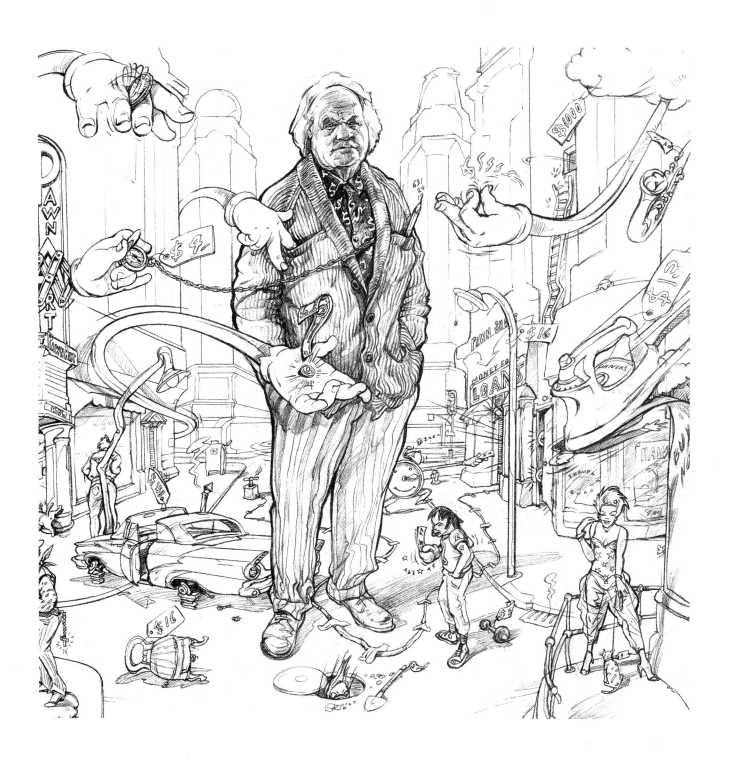

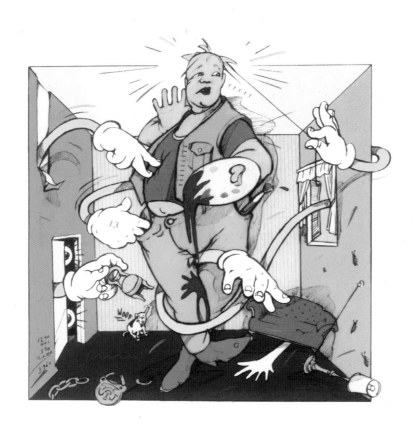

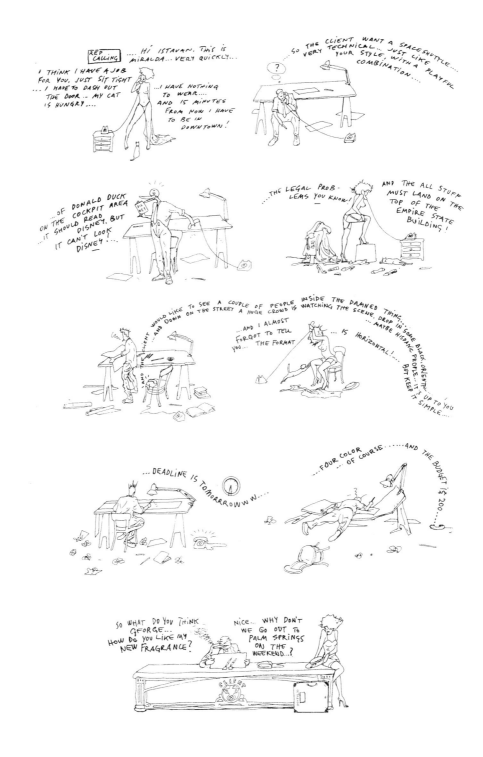

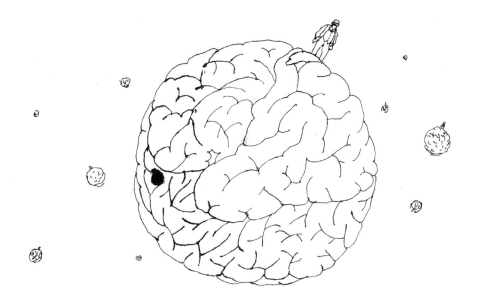

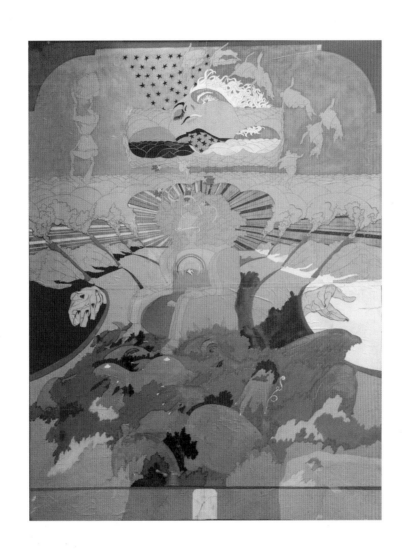

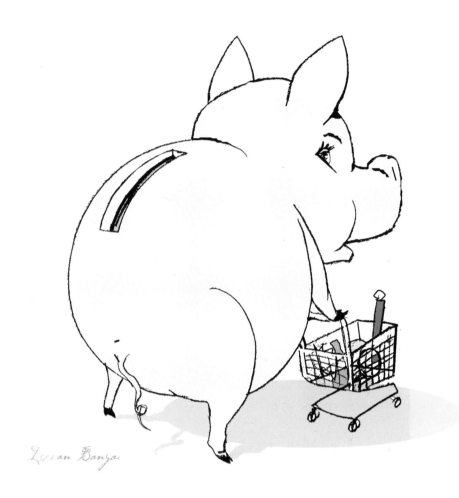

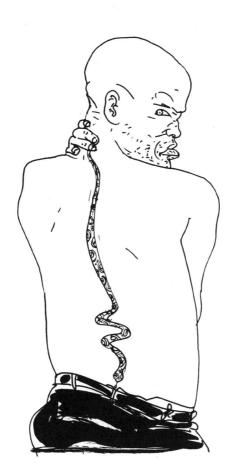

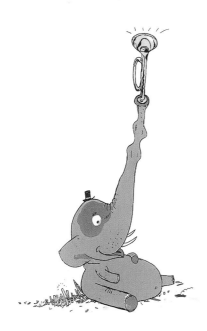

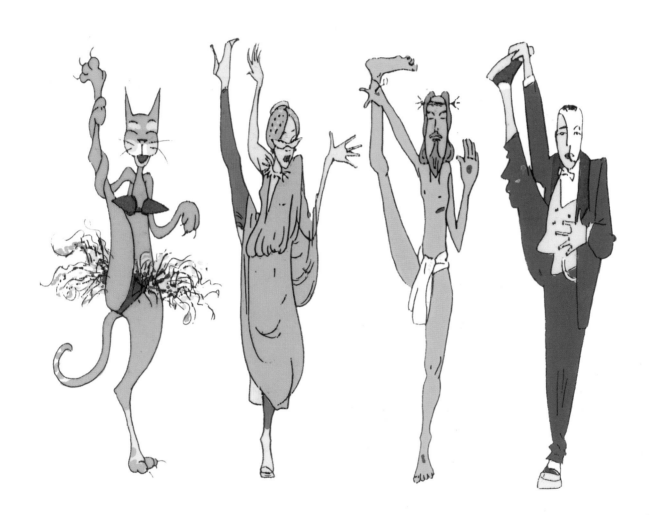

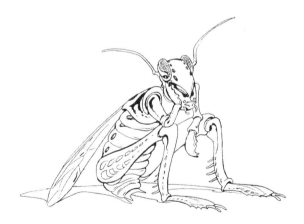

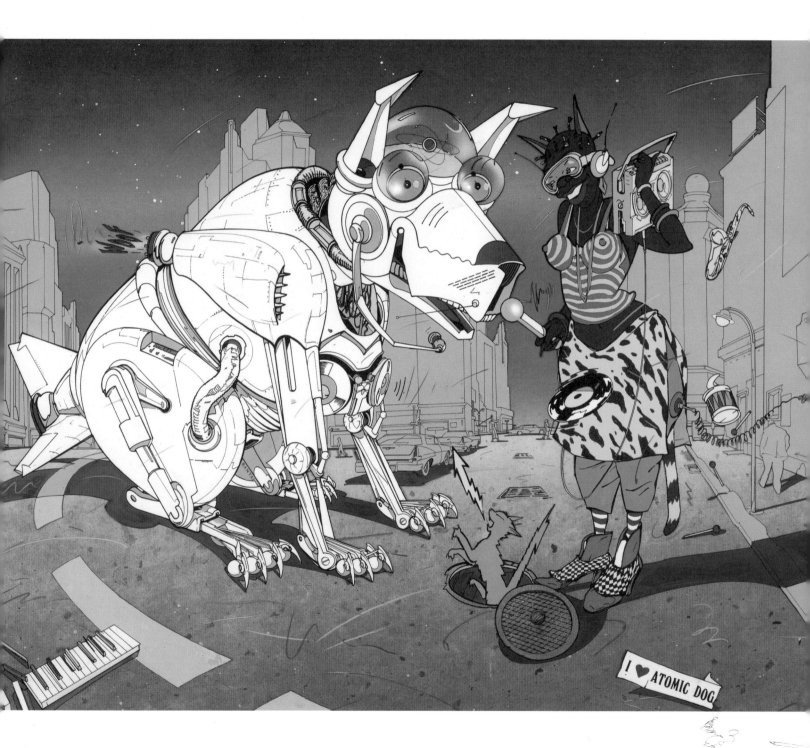

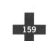

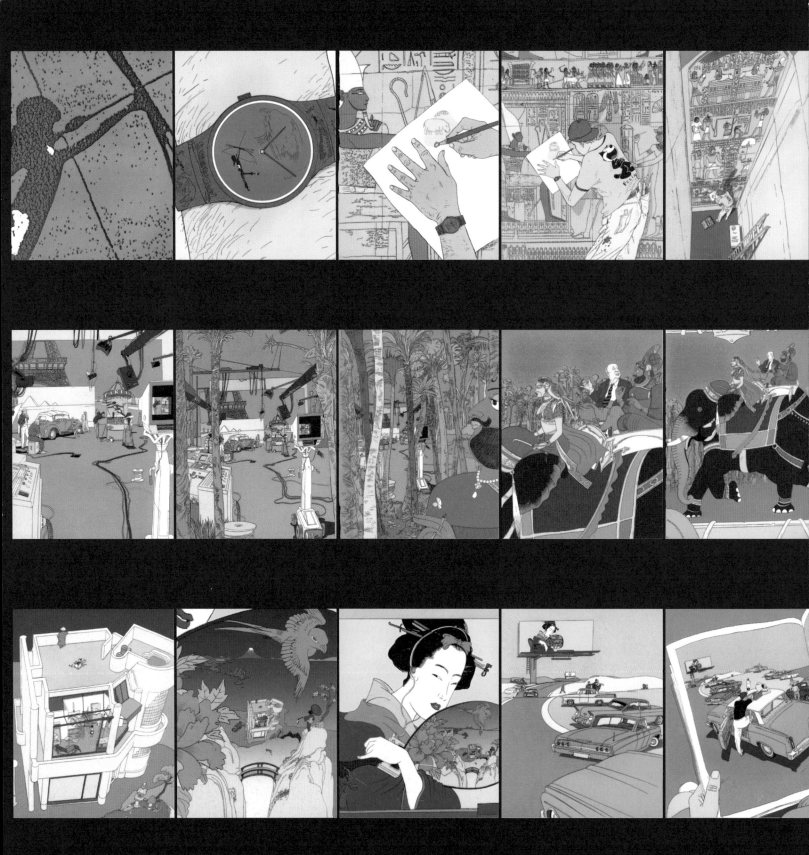

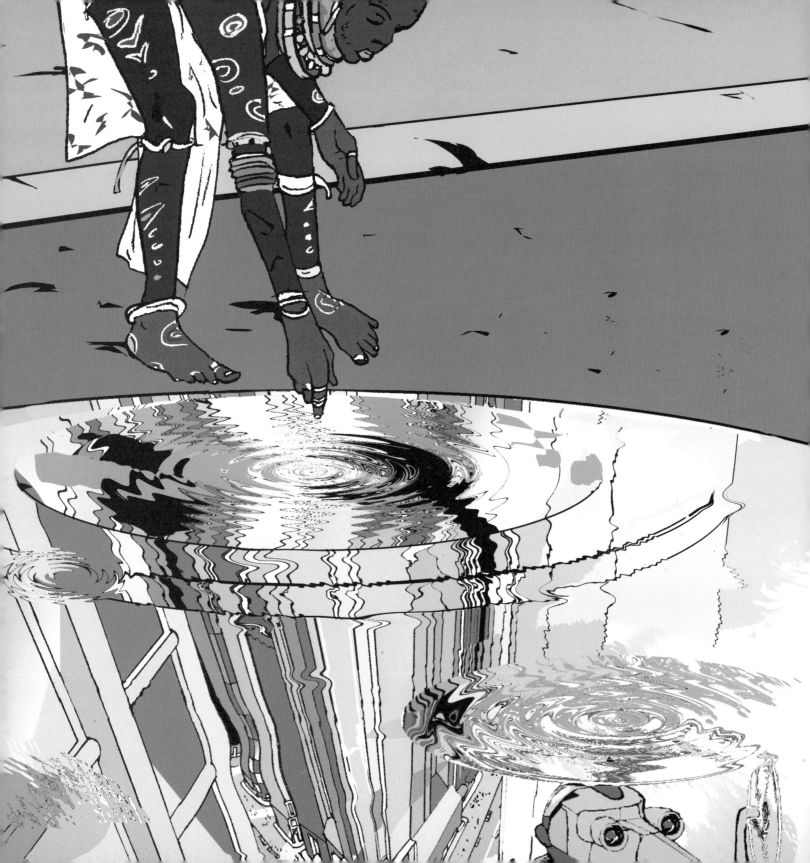

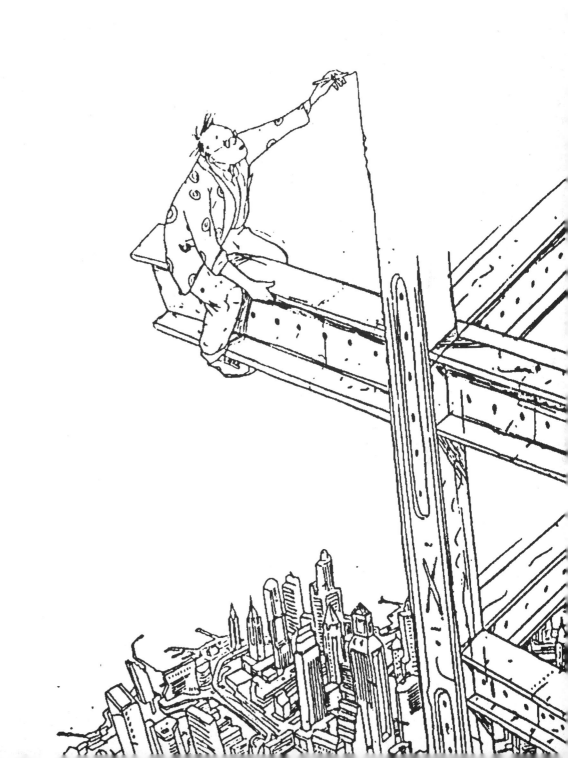

CHAIRS

AND LEGS

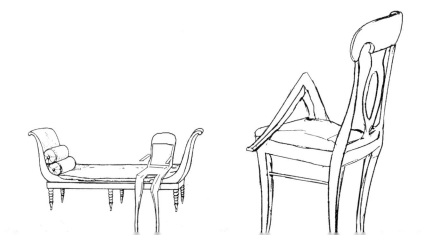

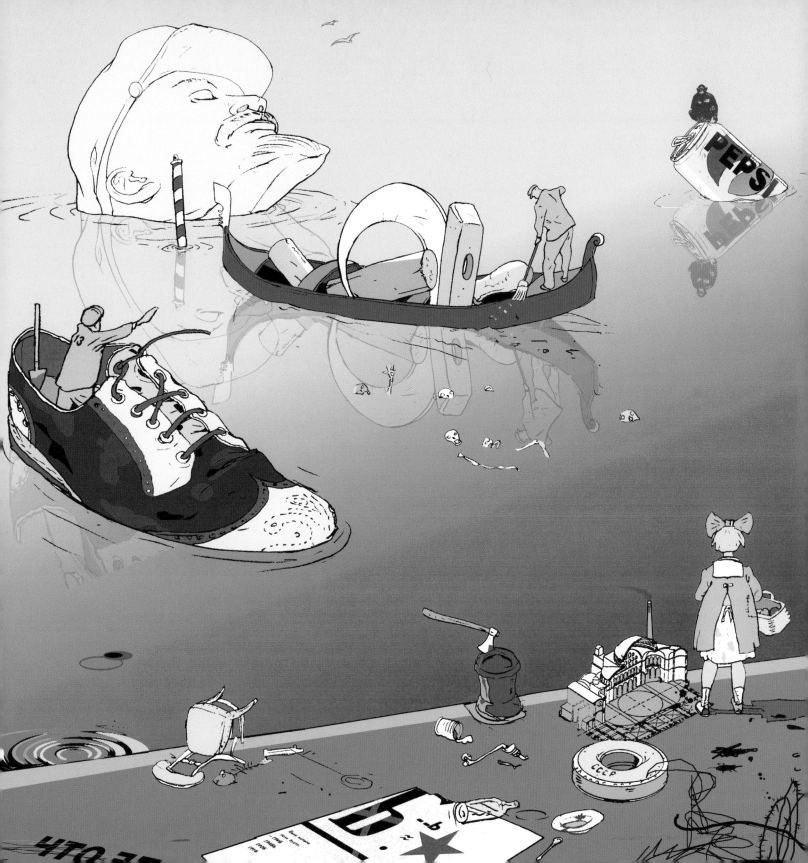

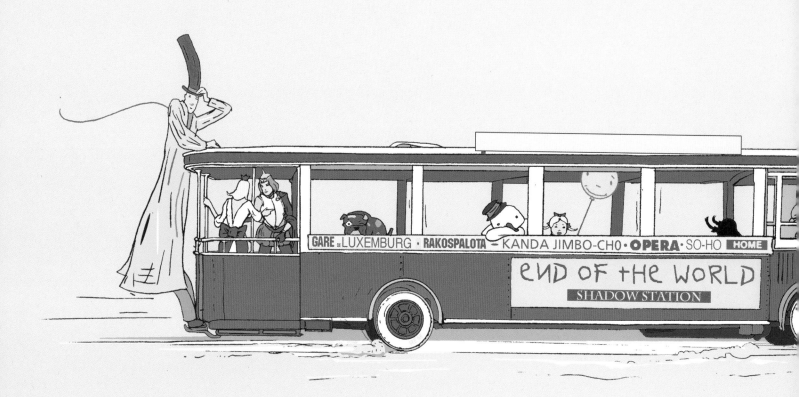

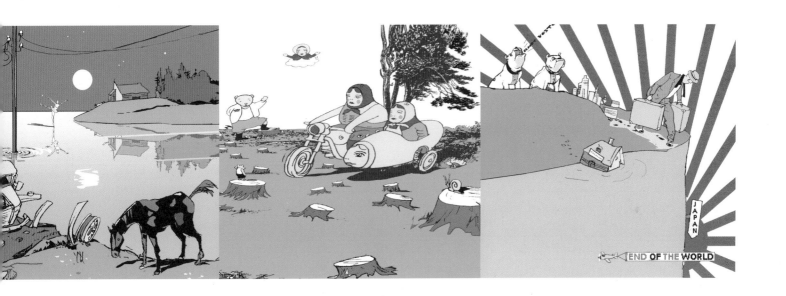

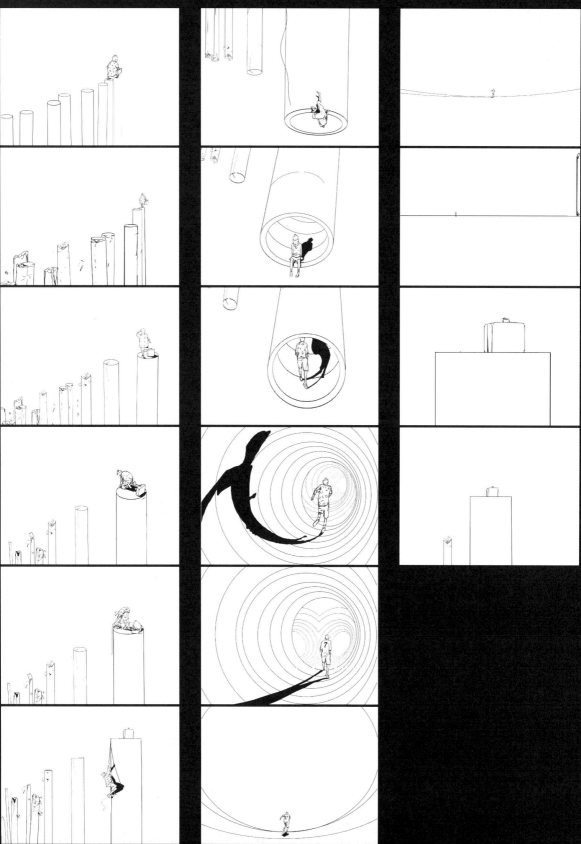

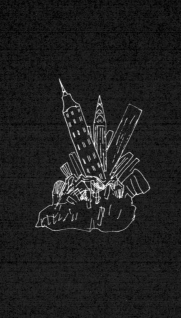

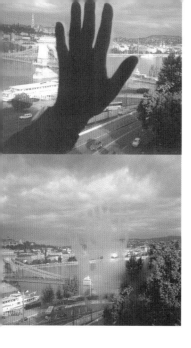

Tárgy: Jogellenesen külföldön tartózkodás
megállapítása.

Bányai István
Budapest
Vág u.63.
1155

Statement: Illegally abroad//Hungarian police. 1980 Budapest

REPUBLIQUE FRANÇAISE

PREFECTURE
DES HAUTS-DE-SEINE

**DIRECTION
DE LA REGLEMENTATION** SAUF-CONDUIT N° 956

3° Bureau

Valable pour UN voyage aller et retour (1)
du 10 JUILLET au 9 OCTOBRE à destination des États Unis d'Amérique
1981 1981
M ᴸ BANYAi prénoms ISTVAN

I was born...

**MY CURRICULUM VITAE,
AS YOU CHOOSE**

I dread knowing precisely my own limitations . . . I hope for the impossible, the chimerical!

—René Magritte

Left: "Toaster." From my sketchbook
Above: "Elephant." 1957

A soppy one:

What a pain it is to be born a *happy child* (by nature) in a paranoid, self-destructive country (this time Hungary, for a change), with a massive imported dictatorship—eager to punish YOU, if you dare to have fun! Growing up with absurd standards teaches you one thing: try to avoid eye contact with a regime that is constantly on the lookout for enemies. Just go biking, have a hobby—or an addiction. The less you have to do with their reality the better.

The cynical Cold-War-child version:

The factory is yours, you just cannot take it home. That's the reason they never built any homes! They want you to have nothing, so you can have everything: very dialectic. End of story.

In capitalism everything is money, so you sell out first and cry "victim" later. Business is *so* glamorous these days. It is our religion! But the bravado of speculation quietly makes everything predictable and boring. Sadly, the product is myself, someone who emigrated from a place that no longer exists to a place where the future is retro.

"Drunk." By my father, c.1930

So, the virtual facts:

As a distant relative of Attila the Hun (a superhero for you), I'm a Central European mongrel who went from biology to architecture to illustration and graphic design . . . ending up fussing with animation. I learned it the hard way, simply by drawing and drawing and motion testing and drawing again, getting a sense of time through the process.

Drawing means the world to me as a form of escape, therapy, discovery, and joy. I am the Creator—whether for five seconds or for a month. I make

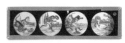

Glass slide from Lanterna Magica

it up. It comes from nothing: zero. There is no such thing as a line in nature! I like *not* to know what I am doing! I pinch the field and the idea comes to me via autopilot.

My childhood education, from elementary school to art school, was strict to the core, very lexical, with Latin and piano lessons on top of everything else. Thirty years later, nothing I learned has any merit, except the Latin declinations and the Chopin mazurkas.

My early art influences—other than Toulouse-Lautrec, Degas, and Klimt's kisser—are Winsor McCay's *Little Nemo*, Folon's faceless little guy in a big environment, Roland Topor's "*merde*"-ish erotica extravaganza, Tomi Ungerer's witty rationale, Heinz Edelman's *Yellow Submarine* fish—doing the breast stroke!—and Pushpin, which, as a psychedelic/Victorian pre-postmodern genre, resonated as far as Budapest.

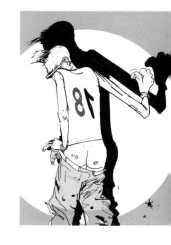

I grew up looking at illustrations in old books from the Austro-Hungarian era—Lazy Peter and the etchings in Jules Verne—and enjoyed watching the painted glass slides on a Lanterna Magica, an early projector, made in Prague in 1905. I've never seen such gems . . . the frog's visit and other banalities—like Shepard's *Winnie the Pooh*: superb quality, just priceless! My stepmother's Japanese hand-painted silk photo albums, a postcard collection sent by her father—before he sank with the *Titanic*—from Hong Kong, Tokyo, and Singapore, added a twist to the European flavor. Together with my real mother's books on how to draw—she was a teacher—these things helped to develop a visual sensibility that was all but missing from the Soviet dew.

My father gave me my first watercolor lesson when I was six, and, interestingly, never wanted to hear about art seriously ever again. He wanted me to be just like him, an engineer. The Beat Generation says hello!

As soon as the Iron Curtain started to rust, I paid hard cash on the black market for magazines like *Tweed* and for LPs such as Janis Joplin's *Cheep Thrills* with Crumb on the cover.

In those days, radios had tubes and Luxembourg sounded static

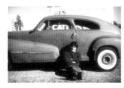

Picture of me in L.A., 1981.
Photograph by Laszló Zsôtér

Armstrong landed on a black-and-white blurry moon.

TV and Cola arrived on the block.

Slowly growing up, my efforts to provide were going nowhere. I made illustrated record covers for rock bands and classical ensembles, and film posters for younger directors and museums . . . and an animated short, called *Hamm* (*Gobble-Gobble*). It's about a little guy who goes into a restaurant and eats his way through everything in the world. When he eats the sun he turns into a fried egg and gets served to the next customer. This was such an overwhelming amount of work—four thousand drawings done in my spare time—that, toward the end, my wife offered to help paint cels just so that, after four years, it could be finished.

I started to gain an underdoglike popularity among my generation: I went as far as you can without kissing up to anyone!

Before my collapse, the helping hand of Fate came out of the stardust like lightning, when the Pannonia film studio, for whom I worked on a free-lance basis, took up an hour-long feature (called *The Lords of Time*) for French TV. Claiming that my work was useless, they fired me, but still used my work anyway.

Regardless of their opinion, René Laloux—who directed *Savage Planet* with Roland Topor—liked my work. He was confident that I could fake Moebius, who designed the new film, and that I would probably be extremely happy to go to France . . . as cheap labor. He was right! To start with, I went just for the job, but after earning some spare change, I dropped off my Hungarian passport with the Versailles Police near Trianon. My project was finally to sort things out for REAL. It resulted in my *emigration*: a surgical move to begin everything all over again; this time without language, without money, without a clue about the latest trend, and with a six-year-old son about to start school.

It took some guts and naiveté, and I take credit for that. I felt like a Buddha, floating upstream on the river for a moment.

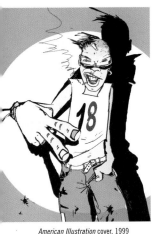

American Illustration cover, 1999

My son's sketch of Papa

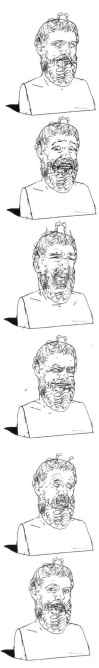

"Aristotle Smiling." Illustration for Encyclopaedia Britannica, 1998

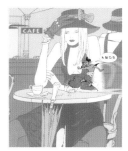
Catalogue cover for Roma 2000 exhibition

The rest is luck, work, obeying the law, paying my taxes, and learning new lessons—nothing much!—a very introspective journey. I've had a lot of help along the way. It would be almost impossible to reciprocate. My flat little universe got rounded up . . . things started to develop from nothing to something: you might say my − equals my +.

Frustration is good, it fuels problem solving.
An uninhibited attraction to the subject is necessary for the outcome.
I like to touch art in museums.

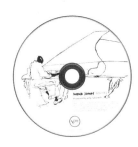
Illustration for Hank Jones CD.
Verve Records, 1997

My work is an organic combination of turn-of-the-century Viennese retro interjected with American pop, some European absurdity added for flavor, served on a cartoon-style color palette and garnished with miniature details—*but absolutely no social realism* added.

10% inspiration, 90% sweat
100% natural

It's all just gravity; I know nothing! I have been here, wondering why, and never really finding a satisfactory answer. That's about it. I see myself as an organism, momentarily consisting of chemical elements that have been spinning around since the Big Bang. So much for my fifty years on Earth: a nanosecond's animated metamorphosis. My ID number is good at a certain temperature and pressure, and distance from the Sun, surrounded by plenty of vegetation, high up on the food chain, etc. I'm a walking contradiction, always on the move, trying to rest—but with nowhere to do so—witnessing the breakdown of my youth along with the surrounding "human" institutions, concepts, value systems . . . and furniture! Suddenly my private history becomes human history, ready to collapse under its own weight: recycled. The rest is specifics.

Istvan Banyai

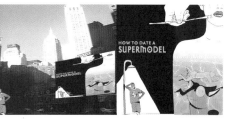
"How to Date a Supermodel." Rejected by *Playboy*, 1997

745 ONLX

1241 9th St...
Santa Monica, CA 90401

Istvan Bamyaz
1241 9th Street
Santa Monica, CA 90401

8STVAN BANYAIT
1241 9th Street
Santa Monica, California 90401

A

Istvan Banyei
1241 9th Street
Santa Monica, CA 90491

PO 56124
IFTVAN BANYOI
32622 VULLEYHEART DR
STUDIO CITY CA 91854

880

Istran Banyai
1241 Ninth Street #3
90401

m 315

AVE

ist 1 inc.

01 000302
KATALIN BANYAL
1241 9TH ST APT 3
SANTA MONICA CA 904

i Banzi rm 315

Istuan Bayai
1241 9th Apt. 3
Santa Monica, CA 90401

I
6
N

Istvan Banyhi
1241 9th Street, #3
Santa Monica, CA 30401

STEVEN BENYA
1241 9TH ST APT. 3
SANTA MONICA CA 90401

Sti Banzai
1241 9th St
Santa Monica, Ca

It is a
cumentation
eritage.
llars and
rough 70
cated

PERMIT NO. 50

Kati Banyar 8-8-85 hm
Take 2 capsules twice daily

Islistvah Banyai

BANZAI ISTUAN
1241 9TH ST.
SANTA MONICA, CA.

Mr. & Mrs. Istvan
1241 9th St., Spt. #3
Santa Monica, CA 90401

e,
re is only
very

THERE WILL
nited to
90t will be
o
ti
rs
ne

B Istavan

1241 9th St.

Santa Monica, CA

90401

ITSVAN
12 RUE
LEVALLO

2
Banyai, Ishtavan
1241 9th St, Ste. 3
Santa Monica CA 90401

Istaban Banya
666 Greenwich Street #624

LIST OF
ILLUSTRATIONS

48 Illustration for the Gotham section of *New York* magazine, 1995. Art Director: Syndi Becker.

49 Illustration for the Gotham section of *New York* magazine, 1996. Art Director: Syndi Becker.

Illustration for the Shouts and Murmurs section of *The New Yorker*, 2000. Art Director: Matt Dellinger.

50 Frames from *Hamm* (*Gobble-Gobble*), a six-minute animated film by Istvan Banyai, 1976.
Post Production: Pannonia Film, Budapest.

52 "Noodle Soup." From my sketchbook, 1994.

53 "Tsunami." Illustration for *Los Angeles Magazine*, 1997. Art Director: Holly Caporale.

54 Cover for *Flatiron* magazine, 1999. Art Director: Andy Omel.

55 Illustration for *Details*, 1998. Art Director: Robert Newman.

56 "Heroin Chic." Illustration for *Playboy* magazine (May 1995, pp66-67). Art Director: Tom Staebler. Copyright © 1995 by *Playboy*. Reprinted with permission.

57 Christmas Card rejected by *Playboy*, 1995.

58 Assorted spots and sketches.

60 *Steve Turre: Lotus Flower*. Mini poster for CD packaging. Verve Records, 1999. Art Director: Chika Azuma.

61 Map of Indonesia for *Art & Antiques*, 1995. Art Director: Janet Parker.

62 Map of Boston for *Art & Antiques*, 1995. Art Director: Chris Lione.

63 Map of Los Angeles for *Art & Antiques*, 1994. Art Director: Chris Lione.

64 Map of Arizona for *GQ* magazine, 1992. Art Director: Janet Parker.

65 Map of Beverly Hills for *Fifty Maps of L.A.* Spade & Archer, 1989. Art Director: J.C. Suares.

66 Illustration for the Shouts and Murmurs section of *The New Yorker*, 1999. Art Director: Chris Curry.

Illustration for the Gotham section of *New York* magazine, 1997. Art Director: Rommel Alama.

67 Illustration for *Money* magazine, 1993. Art Director: Tracy Churchill.

68 Illustration for *Scenario* magazine, 1997. Art Director: Andrew Kner.

69 Silhouette plays on Mozart. Rejected by *The New Yorker*, 1998.

70 Illustration for the Shouts and Murmurs section of *The New Yorker*, 1999. Art Director: Matt Dellinger.

71 "Exposed in New York." For *The New Yorker*, 1998. Art Director: Chris Curry.

72 "Laptop." Rejected by *Rolling Stone*, 1996. Art Director: Fred Woodward.

"Girltalk." Illustration for Japanese *Playboy*, 1997. Art Director: Juri Tanaka.

73 Illustration for a story called "The Upper Room," about virtual reality. Published in *Playboy* magazine, 1996.
Art Director: Kerig Pope.

74 Various pieces on sexual conduct, in the bedroom or on the Internet. Published in *Playboy* magazine.

75 "Girltalk." Published in Japanese *Playboy*, 1996. Art Director: Juri Tanaka.

76 "College Erotica." Published in *Playboy* magazine, 1998. Art Director: Kerig Pope.

77 "Girltalk." Published in Japanese *Playboy*, 1996. Art Director: Juri Tanaka.

78 Animated sequence from Jean-Michel Jarre's animated music video *Oxygène 13*.
SONY, MTV Europe/Dreifus Music, Paris, 1998.

80 "Taboo." From *The Slang of Sin*, by Tom Danzell. Merriam Webster, 1998. Art Director: Bob Ciano.

81 "Girltalk." Published in Japanese *Playboy*, 1997. Art Director: Juri Tanaka.

82 "Advisors." Published in *Playboy* magazine, 1992–2000. Art Director: Bruce Hansen.

84 Ki Beszél itt Szerelemröl? (*Who is Talking About Love?*). Rejected sketch for Hungarian film poster, 1978.

85 "Girltalk." Published in Japanese *Playboy*, 1996. Art Director: Juri Tanaka.

86 Cover idea for *American Illustration* No. 18. Art Directors: Emily Crawford, Gretchen Smelter, and Patrick Michell.

88 "The Social History of Rock Stars and Supermodels." Full page in *Playboy* magazine (May 1996, pp108-109).
Art Director: Kerig Pope. Copyright © 1996 by *Playboy*. Reprintd with permission.

89 "Sex, Home and Videotape." Full page in *Playboy* magazine (November 1995, pp114-115). Art Director: Kerig Pope.
Copyright © 1995 by *Playboy*. Reprintd with permission.

"Mr. Pisces." From my sketchbook

90 *Left:* Illustration for *Details*, 1998. Art Director: Robert Newman.

 Right: "Girltalk." Published in Japanese *Playboy*, 1996. Art Director: Juri Tanaka.

 "Girltalk." Published in Japanese *Playboy*, 1998. Art Director: Juri Tanaka.

91 Rejected CD cover for *Gershwin's World* by Herbie Hancock. Verve Records, 1998.

92 Rejected cover ideas for *The New Yorker*, 1996–2000, with one exception on the bottom right, about tax day 1997!
 Art Director: Françoise Moully.

93 Rejected cover idea for *The New Yorker* based on *Picasso's Women*, an exhibition held at MoMA, New York, in 1998.

94 Illustration for *Reader's Digest*, 2000. Art Director: Lanu Hakso.

95 Drawing of my son, Simon, for his high school graduation yearbook, 1992.

96 Idea project for Saatchi and Saatchi, London, 2000. Creative Director: Richard Myers.

97 Animation from *Drum Earth*, a personal project, 1993.

98 "U2 in Vegas." For *Rolling Stone*, 1998. Art Director: Fred Woodward.

99 "Throw up a Hand." An illustration from *The Slang of Sin* by Tom Danzell. Merriam Webster, 1998. Art Director: Bob Ciano.

100 "Odds." From *The Slang of Sin* by Tom Danzell. Merriam Webster, 1998. Art Director: Bob Ciano.

101-105 Character development for the animated project *Fashion Alley*. © Schlaifer Nance & Co. and TADC. All rights reserved.
 The three left-hand figures on page 102 are from a *Time* magazine special edition, 1995.
 Art Director: Walter Bernard/WBMG.

106 Poster for the Hungarian release of Fellini's *Casanova*, 1976. MOKEP Art Director: Agnes Farago.

107 Poster for the 100th birthday of Ady Endre, a Hungarian poet of the Belle Epoque. For an exhibition at the Literary
 Museum, Budapest, 1977. Art Director: Agnes Somogyi.

108 "Shakespeare in the Park." For *New York* magazine. Art Director: Robert Newman.

109 "Madonna." For *New York* magazine, 1997. Art Director: Robert Best.

110 "Lincoln." Illustration for a schoolbook published by Scholastic, 1985.

111 Poster for the Hungarian release of Fellini's *Prova d'Orchestra*, 1998. MOKEP. Art Director: Agnes Farago.

112 Drawing of an infinite horizontal landscape, done at the age of eight . . . in 1957.

113 "Békeharz" (Fighting for Peace). From my sketchbook, 2000.

114 Illustrations for the Gotham section of *New York* magazine, 1996. Art Director: Andrea Dunham.

115 "Video Games." For Amiga World. The Pushpin Group, 1986.

116 Bugs and planes from my sketchbook.

117 "Environmental L.A." For *Fifty Maps of L.A.* Spade & Archer, 1990. Art Director: J.C. Suares.

118 *Top:* Sequence from a calendar for the Hungarian oil company MOL, 1998. Art Directors: Gyula Benczúr and András Zakar.

 Bottom: A *Details* party invitation, 1998. Art Director: Robert Newman.

119 "Party in Manhattan and in Washington D.C." In the Lifestyle section of *The New York Times*, 1998.
 Art Director: Jerelle Kraus.

120 "Yuppie parents on drugs." Illustration for *7 DAYS* magazine, 1995. Art Director: J.C. Suares.

121 Illustration for the Gotham section of *New York* magazine, 1997. Art Director: Syndi Becker.

122 Illustration from *Pelote et Victoire*, a children's book by Paule du Bouchet. Gobelune/Hachette, 1981.
 Art Director: Colline Faure-Poirée.

124 Illustration for the Shouts and Murmurs section of *The New Yorker*, 1998. Art Director: Matt Dellinger.

125 "Cooking." From the "Hippie" chapter of *Flappers 2 Rappers: American Youth Slang*. Merriam Webster, 1996.
 Art Director: Bob Ciano.

126 "Menu." For *MacWeek*, 1986. Art Director: Laslo Vespremi.

127 Illustration for the Gotham section of *New York* magazine, 1995. Art Director: Syndi Becker.

128-130 Characters from Jean-Michel Jarre's animated music video, *Oxygène 13*.
 SONY, MTV Europe/Dreifus Music, Paris, 1998.

Idea drawing for *Business Week*, 1985

131 Sketch done as a fresh émigré in Paris, 1980.

Stamps for ROMA 2000, an exhibition of American illustration held in Rome, March 2000.

132 Little heads from *Poems for Children Nowhere Near Old Enough to Vote*, by Carl Sandburg. Knopf, 1999. Editor: Janet Schulman. Art Director: Isabel Warren-Lynch.

133 "Fuck up." From the "Hippie" chapter of *Flappers 2 Rappers: American Youth Slang*. Merriam Webster, 1996. Art Director: Bob Ciano.

134 "La Veneziana." For *Playboy* magazine (August 1995, pp54-55). Art Director: Kerig Pope. Copyright © 1995 by *Playboy*. Reprinted with permission.

135 Mixed heads from sketchbooks, except ".com," which was published in *The New Yorker* in 1999.

136 "Timequake." For *Playboy* magazine (December 1997, pp100-101). Art Director: Kerig Pope. Copyright © 1997 by *Playboy*. Reprinted with permission.

137 "WEB." For *Atlantic Monthly*, 1997. Art Director: Judy Garlan.

138 "Planet." From *Poems for Children Nowhere Near Old Enough to Vote* by Carl Sandburg. Knopf, 1999. Editor: Janet Schulman. Art Director: Isabel Warren-Lynch.

"Fractal," from my sketchbook.

139 "The Congress and the President." For *The New York Times* Op-Ed page, 1998. Art Director: Nicholas Blechman.

140 Sequence for *Fractal* (an animated short film), 1999. Unreleased.

142 "Nixon on the Cold War." For *The New York Times* Op-Ed page, 1996. Art Director: Jerelle Kraus.

143 Untitled. From my sketchbook, 1984.

144 Illustration for *Scenario*, 1997. Art Director: Andrew Kner.

145 "Celebration, Florida." For *The New Yorker*, 1999. Art Director: Chris Curry.

146 Rejected film poster for *Sneakers*, 1983. Composition board in pencil.

147 "Break-in." For *California Magazine*, 1982. Art Director: Nancy Duckworth.

148 "Artist's representative." From my sketchbook, 1988.

149 From my art school sketchbook, 1970.

150 "Private Icon." Diploma poster piece, Academy of Applied Arts, 1972. Teachers: Gyorgy Haiman and Janos Kass.

152 "Yen." For *The New York Times* Op-Ed page, 1998. Art Director: Nicholas Blechman.

153 "Mondrian." Illustration for the Gotham section of *New York* magazine, 1997. Art Director: Syndi Becker.

154 Illustration for the Shouts and Murmurs section of *The New Yorker*, 1999. Art Director: Matt Dellinger.

155 Sketch for *The Slang of Sin* by Tom Danzell. Merriam Webster, 1998. Art Director: Bob Ciano.

156 *Left*: "Republican House." For the Gotham section of *New York* magazine, 1996. Art Director: Syndi Becker.

Right: Sequence from Jean-Michel Jarre's animated music video *Oxygène 13*. SONY, MTV Europe/Dreifus Music, Paris, 1998.

157 "Broadway" (*Cats, Sunset Boulevard, Jesus Christ Superstar,* and *Phantom of the Opera*). For the Gotham section of *New York* magazine, 1996. Art Director: Syndi Becker.

158 "Cricket." From my sketchbook, 1973.

159 Poster for George Clinton's *Atomic Dog*. Capitol Records, 1983. Art Director: Roy Kohara.

160 *Re-Zoom*, a children's book written and illustrated by Istvan Banyai. Viking Penguin, 1996. Publisher: Regina Hayes.

162 "Third World." From brochure for MSNBC project, 1996.

163 "Artwork." For *Print* magazine, 1988. Art Director: Carol Stevens.

164 Chairs and legs from *Poems for Children Nowhere Near Old Enough to Vote*, by Carl Sandburg. Knopf, 1999. Editor: Janet Schulman.

165 "P.J. O'Rourke Deep in the Heart of Siberia." For *Rolling Stone*, 1996. Art Director: Fred Woodward.

166 From the children's book *R.E.M.*, written and illustrated by Istvan Banyai. Viking Penguin, 1997.

167 "P.J. O'Rourke Deep in the Heart of Siberia." For *Rolling Stone*, 1996. Art Director: Fred Woodward.

168 Personal book project, 1972.

169 "Crystal." From my sketchbook, 1988.

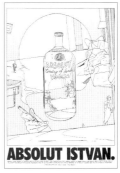

"Absolut Istvan." 1997

Acknowledgments

Thanks to Paul Gottlieb of Abrams, who decided to publish
this book. To Roger Schlaifer, for introducing me to Paul.
To Kurt Andersen and Robert Best, who put me on the
pages of *New York* magazine, where Roger found me. To all
who gave me a chance to collect a portfolio that caught the
eyes of Robert and Kurt. . . . So it goes!

Library of Congress Cataloging-in-Publication Data

Banyai, Istvan.
 Minus equals plus / by Istvan Banyai with an introduction
 by Kurt Andersen.
 p. cm.
ISBN 0–8109–2990–2
1. Banyai, Istvan. I. Title.

NC975.5.B358 A4 2001
741.6'4'092—dc21 00–049337

Cover and book designed by Chika Azuma

Printed and bound in Hong Kong

Harry N. Abrams, Inc.
100 Fifth Avenue
New York, N.Y. 10011
www.abramsbooks.com